Basic Nature Painting

TECHNIQUES IN

WATERCOLOR

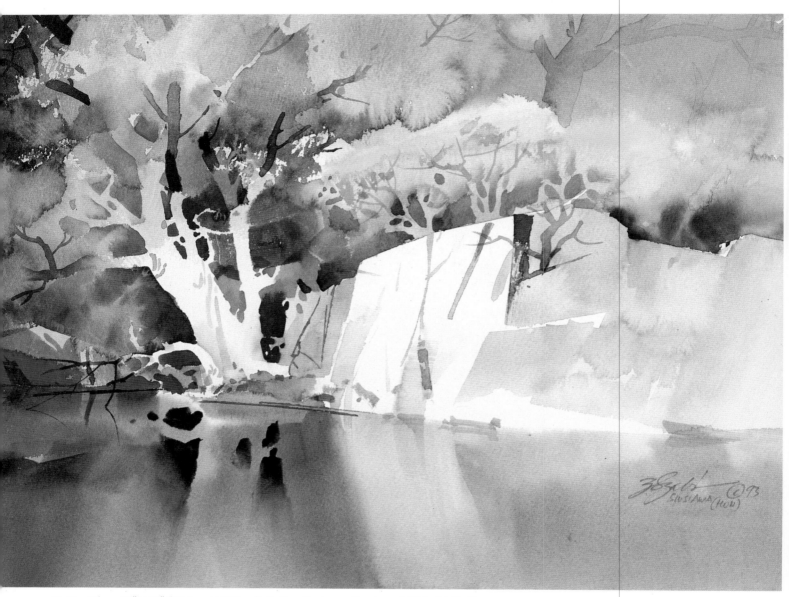

Happy Glow, 15″ × 20″ (38.1cm × 50.8cm), Zoltan Szabo, collection of Willa McNeill.

Basic
Nature
Painting
TECHNIQUES IN
WATERCOLOR

Edited by
RACHEL RUBIN WOLF

NORTH LIGHT BOOKS
CINCINNATI, OHIO

Other fine North Light Books are available from your local bookstore, art supply store or direct from the publisher.

02 01 00 5 4 3 2

Library of Congress Cataloging-in-Publication Data

Basic nature painting techniques in watercolor / edited by Rachel Rubin Wolf.—1st ed.
 p. cm.
Includes index.
ISBN 0-89134-852-2 (alk. paper)
 1. Nature (Aesthetics) 2. Watercolor painting—Technique. I. Wolf, Rachel.
ND2237.B37 1998
751.42'243—dc21 97-36217
 CIP

Edited by Rachel Rubin Wolf
Content Edited by Glenn L. Marcum
Production Edited by Michelle Kramer
Cover designed by Kathleen DeZarn
Cover illustration by Judi Wagner

The material in this compilation appeared in the following previously published North Light Books and appears here by permission of the authors. (The initial page numbers given refer to pages in the original work; page numbers in parentheses refer to pages in this book.)

Hill, Tom. *Painting Watercolors on Location With Tom Hill* © 1996. Pages 10-15, 33-39, 24-31 (pages 100-105, 109-123).

Johnson, Cathy. *First Steps Series: Painting Watercolors* © 1995. Pages 6-15 (pages 10-19).

Katchen, Carole. *Make Your Watercolors Look Professional* © 1995. Pages 42-43, 91-93, 112-113 (pages 94-95, 98-99, 106-108).

Lawrence, Skip. *Painting Light & Shadow in Watercolor* © 1994. Pages 52-53, 56-59, 27-28, 60-70, 96-99 (pages 68-73, 76-83).

Nice, Claudia. *Creating Textures in Pen & Ink With Watercolor* © 1995. Pages 86-89, 51-52 (pages 30-43, 66-67).

Reynolds, Robert, with Patrick Seslar. *Painting Nature's Peaceful Places* © 1993. Pages 58-59, 54, 56-57, 60-61, 66-67 (pages 84-91).

Richards, David P. *How to Discover Your Personal Painting Style* © 1995. Pages 12-13 (pages 124-125).

Rocco, Michael P. *Painting Realistic Watercolor Textures* © 1996. Pages 28-31, 10-13, 6-9, 24-27, 14-15, 22-23 (pages 44-59, 62-65).

Szabo, Zoltan. *Zoltan Szabo's 70 Favorite Watercolor Techniques* © 1995. Pages 52-55, 58-59, 98-99, 80-81, 56-57 (pages 20-29, 60-61).

Wagner, Judi and Tony van Hasselt. *Painting With the White of Your Paper* © 1994. Pages 92-93, 60-61 (pages 74-75, 96-97).

Wiegardt, Eric. *Watercolor: Free & Easy* © 1996. Pages 92-93 (pages 92-93).

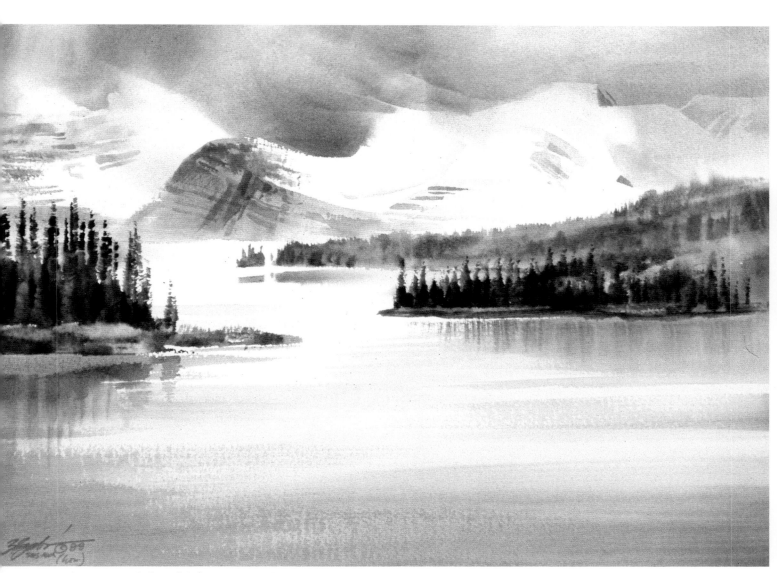

High Country, 14½″ × 20″ (36.8cm × 50.8cm), Zoltan Szabo

ACKNOWLEDGMENTS

The people who deserve special thanks, and without whom this book would not have been possible, are the artists whose work appears in this book. They are:

Charlene Engel	Douglas Osa
Nita Engle	Robert Reynolds
Barbara Luebke Hill	David P. Richards
Tom Hill	Michael P. Rocco
Sharon Hults	Patrick Seslar
Cathy Johnson	Don Stone
Carole Katchen	Zoltan Szabo
Dale Laitinen	Tony van Hasselt
Skip Lawrence	Judi Wagner
Claudia Nice	Eric Wiegardt

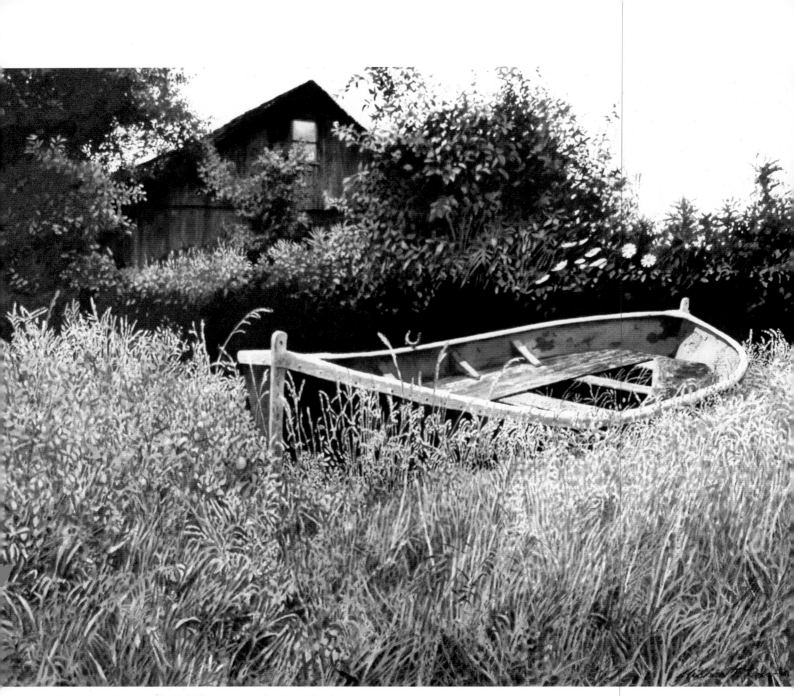

Abandoned Boat, 17″ × 23″ (43.2cm × 58.4cm), Michael P. Rocco

TABLE
of
CONTENTS

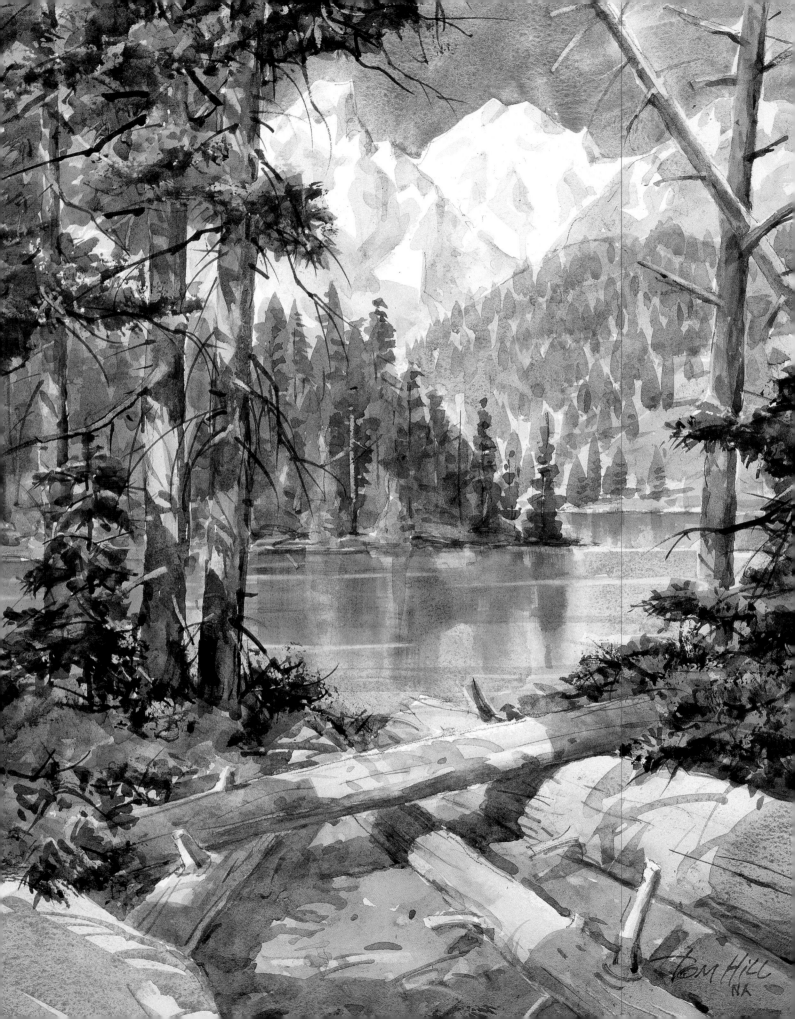

INTRODUCTION

Watercolor so beautifully captures the radiance and purity of color found in nature. In this book, you will learn how to use watercolor's special properties to render realistic paintings of light, trees, mountains and other wonders of nature.

This book is a compilation of some of the best teaching on watercolor and nature painting. We've started the book with useful information on materials, techniques and color. The rest of the book teaches basic principles of nature painting and, through demonstrations, covers the nature painting process from beginning to end. All you will need to be successful is practice and determination. The process is fun and, in the end, you will be rewarded with beautiful paintings of nature.

Tools and Materials

There's a wonderful array of equipment, tools and gadgets out there, all designed to make it easier for you to paint in watercolor. What's a necessity and what isn't is up to you, once you know your way around. But what you need to get *started* is relatively simple.

Basic Materials

The *most* basic supplies for watercolor are paints, paper, brushes, a water container and a palette. The supplies you choose can make the difference between enjoying your work or not. Here is a basic supply list—these items are generally considered typical watercolor necessities. Some of these you'll use; some you won't. There may be others you discover along the way, as well.

- Paper
- Paints
- Brushes
- Painting support
- Palette
- Water container
- No. 2 pencil
- Soft eraser
- Masking or drafting tape
- Paper towels, tissues or rags
- Liquid mask
- Rubber cement pickup

If you find that you prefer to paint big, splashy paintings, a teeny, tiny field box with a few half pans and a no. 4 brush will drive you crazy. If, on the other hand, you have limited space, like to keep things manageable and are most comfortable working on a smaller scale, you won't need the huge inch-wide brushes and full-sized paper supports. Look over the list of basics and choose what's best for you.

Cut in half

or any size you like

or eighths

or quarters

Paper

It isn't necessary to paint full-sheet size (approximately 22″×30″ [55.9cm×76.2cm]). And besides, face it, you *are* going to waste some paper.

Consider cutting the big, full sheets in half or in quarters, or buy a watercolor pad or block of the size you want until you learn your way around.

If price is a consideration, working smaller lets you get by with smaller, less expensive brushes and palettes, and smaller amounts of paint.

If you prefer, you can buy paper in a spiral-bound pad, a hardbound sketchbook or a block. Blocks come in sizes from 4″×6″ (10.2cm×15.2cm) to 18″×24″ (45.7cm×61cm) or larger, allowing plenty of versatility, though you may find that larger-size blocks

TIP

Cold-press paper (140-lb. [300g/m²]) is easiest to handle and is often less expensive than heavier paper or more exotic surfaces—you can't go wrong!

buckle more than you like before drying flat again.

There are three types of watercolor paper available: *hot-press*, *cold-press* and *rough*, which refer to surface texture. This texture is created during the manufacturing process and is determined by the coarseness of the metal screen the paper is dried on, as well as how it is dried. (Is it air dried as is? Weighted down? Pressed with heat added?)

Rough Paper

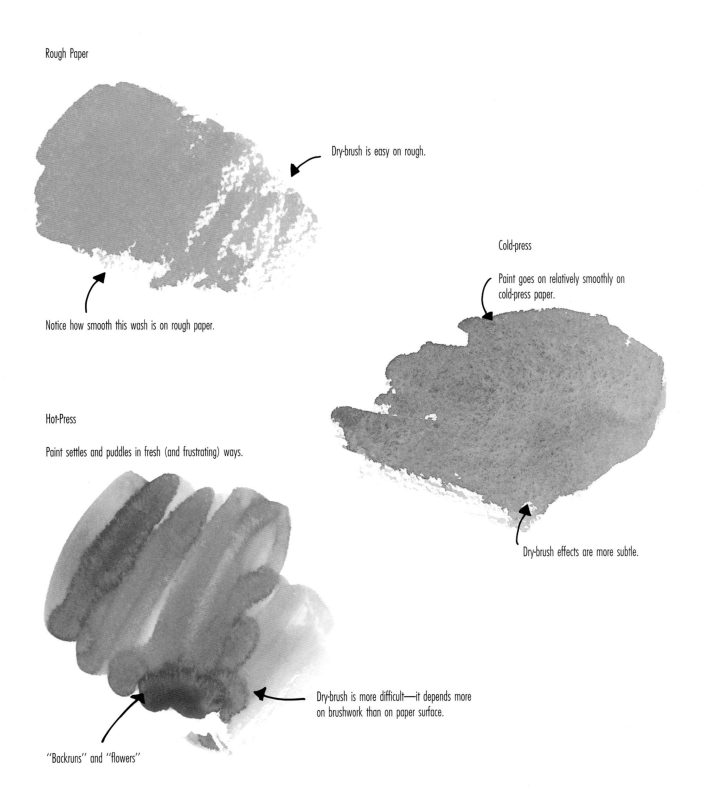

Dry-brush is easy on rough.

Cold-press

Paint goes on relatively smoothly on cold-press paper.

Notice how smooth this wash is on rough paper.

Hot-Press

Paint settles and puddles in fresh (and frustrating) ways.

Dry-brush effects are more subtle.

Dry-brush is more difficult—it depends more on brushwork than on paper surface.

"Backruns" and "flowers"

Look at rough or cold-pressed paper in strong diagonal light—you can see shadows that may "gray" your painting slightly.

This is similar to how the world looks through dark glasses. Watercolor needs light! You can compensate for the shadow effect with good, clear color.

Many watercolorists prefer *rough* paper. In practice, the rough paper's surface makes texturing relatively simple: You can run an almost dry brush over the surface of the little hills, just touching their peaks, to suggest any number of effects. (Those effects, however, will be dictated by the texture of the paper itself.)

Oddly enough, it is easier to do a smooth wash on most rough papers than on any of the other paper options you may choose. The color averages itself out in all those little valleys.

Cold-press paper is somewhere between rough and smooth. Unlike rough, it has been weighted down in the drying process, but without heat added—literally cold-pressed. Its surface is lightly textured—allowing for the best of both worlds.

With cold-press paper, you can create your own textures or take advantage of the subtle texture of the paper itself for dry-brush effects. You can put down a nice graded wash with very little trouble.

Hot-press paper is very smooth because it has been pressed with a hot iron.

With this surface, you create your *own* textures, since the paper has virtually none of its own. It also makes nice *puddles*, or hard-edged shapes, where pools of pigment have dried. These can be very exciting if you are expecting them and plan for them. If you prefer a smoothly blended, wet-in-wet, "misty" effect or more control, use cold-press paper.

Watercolor paper comes in various weights, from 70-lb. (150g/m²) to 140-lb. (300g/m²) to 300-lb. (640g/m²) and more. This refers to the weight of 144 sheets, not to a single sheet. A sheet of 300-lb. (640g/m²) paper is much thicker than the same-size sheet of 70-lb. (150g/m²). The heavyweight stuff doesn't need stretching or taping down to keep it from buckling when painting, no matter how wet you paint.

One-hundred-forty-pound (300g/m²) paper has a nice medium weight and generally doesn't need stretching either—the ripples that may occur in this paper during painting should disappear when it dries. Seventy-pound (150g/m²) paper, on the other hand, buckles badly

when wet. It is the least expensive, though, so if cost is a factor, try it out on very *small* paintings or stretch it before painting for best results. (We'll get to the how-to of stretching a bit further on.)

The designations for "heavier" weights like 555-lb. (640g/m²) or 1,114-lb. (640g/m²) indicate that those

TIP

You might want to buy a paper sampler and explore your options. We all need to take a fresh look at what we're doing and what's available on the market now and again.

Try out rough and cold-press, heavy and light papers. Experiment with the super-absorbent Oriental papers if you like, just to see how they act. Look at this as play—as exploring new territory. You don't have to master them all—just find the ones you like best.

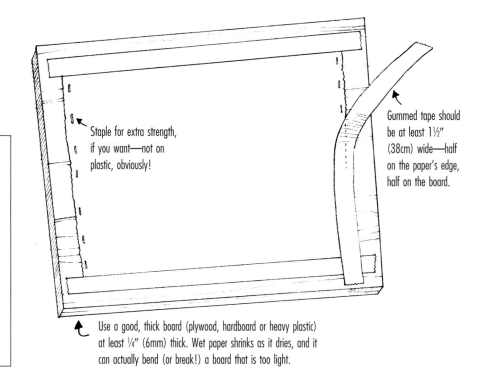

Staple for extra strength, if you want—not on plastic, obviously!

Gummed tape should be at least 1½" (38cm) wide—half on the paper's edge, half on the board.

Use a good, thick board (plywood, hardboard or heavy plastic) at least ¼" (6mm) thick. Wet paper shrinks as it dries, and it can actually bend (or break!) a board that is too light.

TIP

I f you find that you prefer a firm, wrinkle-free surface but don't like to stretch paper, you can buy watercolor board; Strathmore's Watercolor Board is very good. It is expensive, but you can cut the large sheets to any size you like. (Since it has been bonded to a cardboard backing, the rough surface is a bit smoother than unbonded paper.)

papers are larger than 22" × 30" (55.9cm × 76.2cm), not *thicker* than the 300-lb. (640g/m²) designation. Generally speaking, the heavier the paper, the more expensive it is.

Test each of these papers with some of the basic techniques described in chapter two to see which you prefer. You may find that you choose one paper for a specific mood or effect and another for a different purpose.

Sizing affects how your chosen paper takes washes and handles abuse. Without sizing, it would be as absorbent as a paper towel: Smooth washes or crisp edges would be impossible. Sizing also adds strength, allowing you to "get rough" for certain effects without ripping through the paper. On a paper with *lots* of sizing, like Arches, you can scrape, sponge and even sand the surface.

Stretching Watercolor Paper—or Not

It isn't necessary to stretch your paper, even if you're using 140-lb. (300g/m²) in-

stead of the heavier stuff. (Although stretching 70-lb. (150g/m²) paper is recommended.) Instead, tape your paper to your board with 1½" (12mm)-wide masking or drafting tape. What small rippling does occur in the painting process dries flat.

If you *do* want to stretch to achieve a taut surface that resists buckling even under the wettest washes, here's how to go about it:

1. Get a sheet of plywood or Masonite (marine finish but not oil-coated) a few inches larger than the size of your paper. Wet down your paper well on both sides. (Spray it with the dish sprayer in the sink, take it into the shower or soak it in the tub until it's wet through.)

2. Lay your paper on your painting surface and, using wide (at least 1½" [12mm]) gummed tape—the type that must be moistened—fasten it down well on all four edges. Make sure at least half the width of the tape is on the paper.

3. Some artists staple the edge of the paper to the board at close intervals before taping to ensure success—easier to

do on plywood than on fiberboard. Other artists use stretching boards and find they work quite well.

4. Let it dry naturally if time will allow. A hair dryer or other artificial heat source can produce an uneven pull. If possible, for the same reason, let it dry flat rather than propping the support up against the wall. (Gravity pulls the moisture to the bottom, and the top dries first.)

TIP

T he tape provides a clean, white edge. If you want, you can remove it in the middle of a painting—the edge acts as a trial mat and allows you to evaluate your progress. Replace the tape if you feel you're not finished. Make sure your painting is completely dry before removing the tape, though—when the paper is damp it is liable to tear.

Brushes

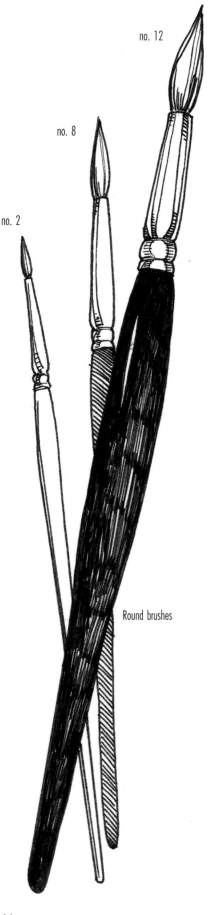

no. 12

no. 8

no. 2

Round brushes

Once upon a time, watercolorists bought several sizes of round red sable brushes and let it go at that. Now we can't get by without a choice of flats, rounds, chisels, fans, bristle brushes and so on.

Quality is important—but there are degrees of quality and reasons for choosing a specific quality level.

Kolinsky, made from the tails of a rare Siberian marten, is the best brush hair available. Soft, springy and thick, Kolinsky makes a wonderful point and holds a lot of water; it's simply the best. Red sable, from the tail of the Asiatic weasel, is slightly less expensive; it, too, is a pleasure to use.

Camel-hair brushes, oddly enough, may not contain any more of a camel than its name; that's a trade name for brushes containing squirrel, pony, bear or goat hair, or any combination thereof. A less expensive brush—one with man-made fibers mixed in with natural animal hairs, like the Sceptre brand—handles differently from sable but is still a viable option.

Some perfectly usable brushes are *completely* man-made, and are much less expensive than Kolinsky or red sable. They may not hold quite as much liquid as the natural-hair brushes, but they have a nice snap and hold a point well.

Round watercolor brushes come in sizes from 000 to 24. Keep a no. 5, a no. 8 and a no. 12 handy: If they maintain a good point, the no. 5s are small enough for details. Sable rounds are prized for their ability to point well and still deliver a load of pigment; the use of sable for other brush types is far less critical. A mixture of natural hair and man-made fibers, or a completely man-ufactured "hair," may be just fine for other brushes.

Flat brushes—sable or otherwise—are often sold by width (half-inch, inch and so on), but they may also be sold by a size number. Try to have a ½-inch (12mm), a ¾-inch (19mm) and a 1-inch (25mm) on hand. Flats may have longer or shorter hairs proportionate to their width: The shorter brushes are easier to handle but don't hold as much water. Some artists prefer them, though, because the longer ones may spring back when you lift them off the page, spattering your work with droplets of color. Look for a brush that's not much longer than it is wide. Many flat brushes come with an angled end (right) on the plastic handle that is excellent for scraping and lifting.

Good brands are Winsor & Newton, Grumbacher, Raphael, Robert Simmons, Masterstroke, Loew Cornell, Daniel Smith, Isabey, Liquitex, Artsign, White Sable and Golden Taklon. A favorite manmade brush is Loew Cornell's La Corneille, which keeps its point for a long time and costs very little.

TIP

Test before you buy, if possi-ble; most good art supply stores offer containers of clear water. Rinse the brush to rid it of siz-ing (brushes are sized for protec-tion during shipping), make a snapping motion with your wrist to flip excess water out, and look to see if the brush has maintained a good point; if it has, buy it.

Beyond Basic Brushes

You may decide to try to get by with tiny little brushes. Don't. It just makes it harder to handle the medium. Tiny brushes don't hold enough liquid and encourage overly tight handling. If price is a factor, try the man-made brushes, but get at least a no. 8 or no. 10 round and ½-inch (12mm) and 1-inch (25mm) flats. You'll want to choose the largest brush you can comfortably work with. It will hold more water and pigment—and cover more ground before needing refilling with fresh paint.

Take care of your brushes. Don't stand them on their tips in water or they'll set up that way. Don't soak them overnight, either; that can soften the glue that holds the hairs in place. A canvas or reed brush holder will protect the tips during travel.

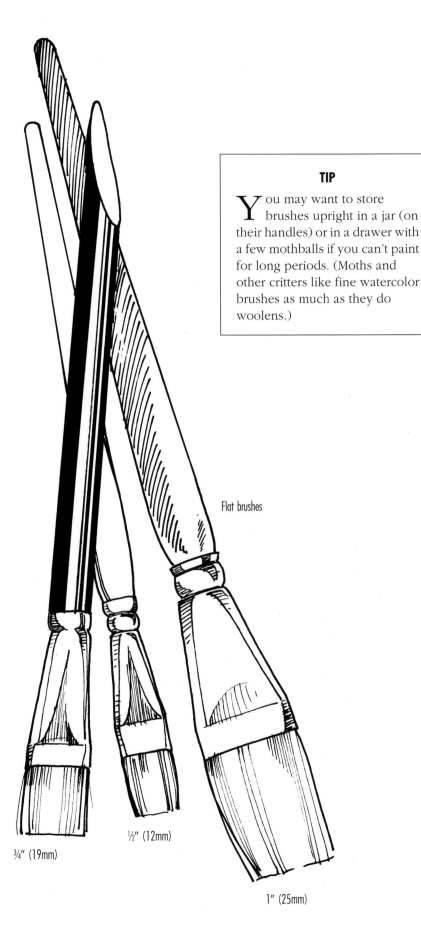

Flat brushes

¾" (19mm)

½" (12mm)

1" (25mm)

TIP

You may want to store brushes upright in a jar (on their handles) or in a drawer with a few mothballs if you can't paint for long periods. (Moths and other critters like fine watercolor brushes as much as they do woolens.)

TIP

Flats and rounds alone will get you by for basic techniques— two or three of each in various sizes is sufficient.

Other Specialized Brushes

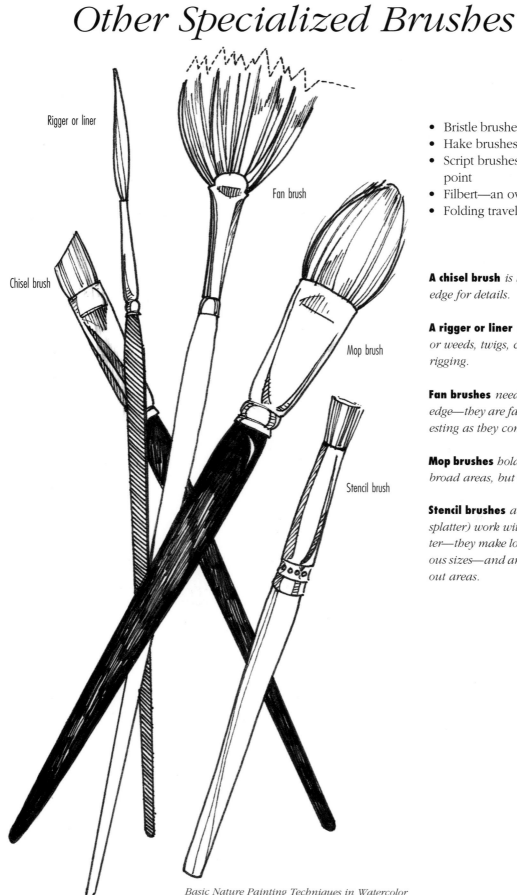

Rigger or liner

Chisel brush

Fan brush

Mop brush

Stencil brush

- Bristle brushes for scrubbing or lifting
- Hake brushes for broad areas
- Script brushes—like riggers with a point
- Filbert—an oval brush
- Folding travel brushes

A chisel brush *is like a flat with a sharp edge for details.*

A rigger or liner *is dandy for tall grass or weeds, twigs, clotheslines and ships' rigging.*

Fan brushes *need to be cut to a jagged edge—they are far too uniform to be interesting as they come from the factory.*

Mop brushes *hold a lot of liquid—good for broad areas, but not detail.*

Stencil brushes *are nice for spatter (or splatter) work with pigment or clear water—they make lots of tiny droplets of various sizes—and are also good for scrubbing out areas.*

Watercolor Paints

For ease of handling and permanence, choose artist-grade rather than student-grade paints. When you're getting started in *any* medium, it's best not to waste time fighting less-than-professional-grade supplies. Choose a limited palette of only a few colors and go with the best.

Try a warm and a cool shade of red, yellow and of blue, plus a couple of earth colors.

- Alizarin Crimson (cool)
- Cadmium Red Medium (warm)
- Phthalo or Antwerp Blue (cool)
- Ultramarine (warm)
- Cadmium Yellow Lemon (cool)
- Cadmium Yellow Medium (warm)

Also get Burnt and Raw Umber and Burnt and Raw Sienna. With just these colors, you can mix all your secondary greens, purples and oranges.

You can supplement this list with a Hooker's Green Dark and a Winsor Green for fast mixing. Use Permanent Rose or a clean, clear lavender to paint spring flowers—Alizarin Crimson just doesn't get it.

An even more limited palette could contain a *single* red, blue and yellow, plus an earth color or two—you sacrifice some purity in the secondaries, but it's a good place to start if price is a serious consideration.

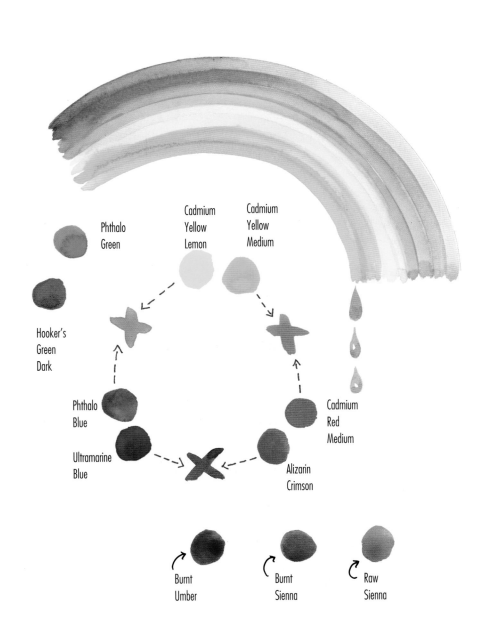

Even a few paints on your palette will make an unlimited rainbow of colors.

The Artist's Palette

Here, we're not discussing the pigments you choose but the surface you mix them on—also called a *palette*. Your palette should have an edge of at least a quarter of an inch to keep washes from spilling, and it should be white to allow you to judge the color and strength of your paint mixtures. A butcher's enamel tray is relatively inexpensive. A high-impact plastic or plastic-and-rubber mix is fine, too, and available almost anywhere art supplies are sold. A white porcelain dinner plate or platter works well, but a palette with dividers around the edge for mounds of paint keeps colors from running together.

The John Pike palette has a lid to protect paints from dust (and cat hair!), and the lid acts as an additional mixing space for big washes. The San Francisco Slant palette is nice, with its variety of mixing wells to keep your washes pure and separate, or you may find that you prefer a smaller, round palette, arranged like a color wheel to organize your paints for quick mixing.

Some Further "Necessities"

- Unless you're using a watercolor block or a good, thick pad, you'll need a *painting surface* to support your paper. Quarter-inch marine plywood is good: Varnish it to make it impervious to water, if you like. Hardboard is another fine choice; be careful to avoid the oil-finished product.

At your art supply store, you can get hardboard painting supports with a handle cut out and big metal clips at one end to hold several sheets of paper. Some artists use a sheet of Plexiglas, which has a nonporous surface that helps hold the moisture in the paper longer.

- *Drafting* or *masking tape* is fine to attach paper to the board (remove it carefully when the painting is bone dry), or you can use *staples* or *Bulldog clamps*, which can be moved during painting.
- *Liquid rubber masks* are helpful for protecting whites when you splash on preliminary washes; Maskoid, Miskit, Liquid Frisket and Incredible White Mask are some familiar brand names.

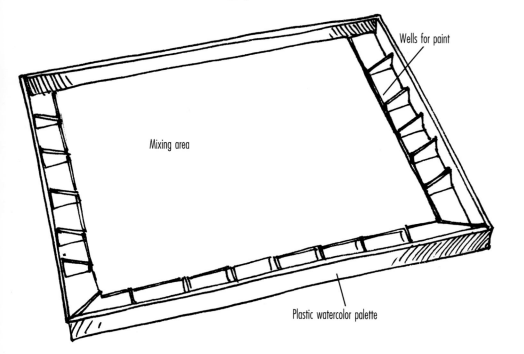

Wells for paint

Mixing area

Plastic watercolor palette

TIP

Pull tape off at an acute angle to your paper to minimize damage or tearing.

TIP

If you use a brush to apply your mask, dampen it with soapy water first so you can easily wash out the rubbery liquid when you're done.

- You'll need a *pencil* and an *eraser*; not too many people paint without guidelines. A no. 2 or HB pencil is basic, but choose the finest, gentlest eraser you can find. A White Magic works well, as does Pentel's Clic Eraser: Neither will damage the surface of your watercolor paper.
- Your *water container* should be unbreakable. For travel, a canteen with a cup works well.
- Use *sponges* to wet paper with clear water, to remove excess sizing, to mop up, to lift color or to paint with. Pick up a selection of natural and man-made sponges.
- Keep *paper towels* or *tissues* handy. A paper towel in one hand and a brush in the other allows you to quickly change the texture of a wash, lighten an area or pick up a bobble or spill so it doesn't even show—if you're prepared.
- A *portable hair dryer* set on warm will speed drying, but keep it moving at a distance of about 18″ (45.7cm) from your paper or you may make hard edges.
- A *spray bottle* can be quite handy for more than moistening dried paint. If an area of your painting has gotten too busy, spray it and flood in a unifying wash. You can soften edges of a wash with a shot of spray, too.

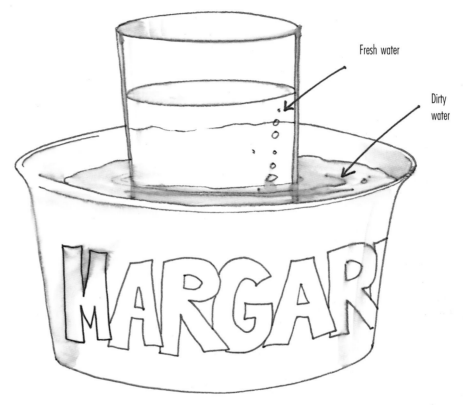

Fresh water

Dirty water

Keep two containers of water handy. You can put one within the other, if you like— try a large margarine tub with a jar in it. Rinse your brush in one, and use the other for mixing clean washes.

TIP

Keep a sponge on your palette (or close by) to absorb extra moisture in your brush, to modify or lighten a wash, or to pick up spills.

Techniques for Painting Trees, Grasses and Earth

Birch Trees

T his scraping technique can be used to paint many kinds of light bark trees, especially against a dark background. The color you choose for your background will affect the color of the light trees. Because Rose Madder (a light-staining color) dominates the area of the light birches in the background, its staining dominance shows up even after the color is squeezed off. Whatever light color you want to show in the scraped-out shape must dominate the background color to start with.

Start with a rich, dark background painted onto dry paper, leaving a negative shape for the large foreground tree. Use Gold Ochre, Rose Madder and Ultramarine Blue Deep. While this thick wash is still tacky wet, lift off the distant birch trunks with the tip of a plastic brush han-dle. Then be ready to dry-brush the texture of the birch bark by quickly dragging across the colors with the edge of a palette knife. Apply the larger branches with the tip of a palette knife held vertically, allowing the liquid paint to flow off as you move the knife away from the trunk.

Background dominated by Rose Madder.

Shape scraped out using plastic brush handle's slanted tip.

Negative shapes left white.

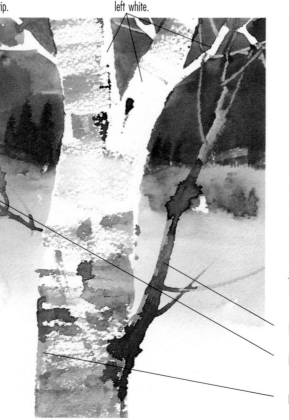

On a wet background, press the slanted edge of the tip of a plastic brush handle as hard as you can, squeezing off the light shapes of the young birches and their branches.

Painted with a palette knife.

Palette knife line contacting damp area.

Palette knife-smeared dry-brush texture.

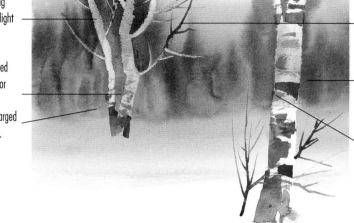

Staining blue showing through scraped-out light shape.

Warm tone was added after background color dried.
Wet, warm colors charged into wet, cool colors.

"Positive" branch shape was painted last with a rigger.

Background was painted first, leaving tree trunks white.

Colorful dry-brush shapes were added last.

While the background wash is still wet, use the slanted tip of the brush handle to remove the birch tree shape. Hold the brush with a firm grip and, with your wrist, press as hard as you can. Hold the flat oval part of the brush handle at a 45° angle to smoothly squeeze the color off without ripping the wet paper.

Although the procedure here was similar to that of the sketch at left, this time the background was painted with varied dominance. As you can see, the scraped-out light birch retained the characteristics in lighter values. The longer you wait to do the scraping, the more time the settling colors have to stain the paper—reducing the contrast somewhat.

Overflow of color moved from lower dark background colors using a brush handle.

Branches scraped out with the back of the brush handle.

Branch shapes were scraped out with the brush handle while the paper was damp but not wet.

Warm accents against cool dominance.

Tap the edge and flat back of the palette knife on the dry white paper to do the peel marks and dry-brush texture at the same time. Use varied colors. Wet paint produces solid shapes; the less water in the paint, the finer the texture.

Leave the upper third of the painting white. As you squeeze the color off, the brush handle acts like a small bulldozer, pushing the wet color in front of itself. In a dark background this color simply blends away. Here, however, the color was deposited on the wet, white background as the brush handle entered it. This free and loose accent engages the edge and prevents the sketch from becoming an unpleasant vignette.

Pine Branches

Most pine branches have little elbows close to the trunk, and the branches reach the needles from the bottom, holding them up with their fingertips. The top of the needle clusters need to be painted with a richly loaded dry brush flipped upward and away from the paper to show the needle-like finish. Do these brushstrokes quickly and decisively: Don't pick at them.

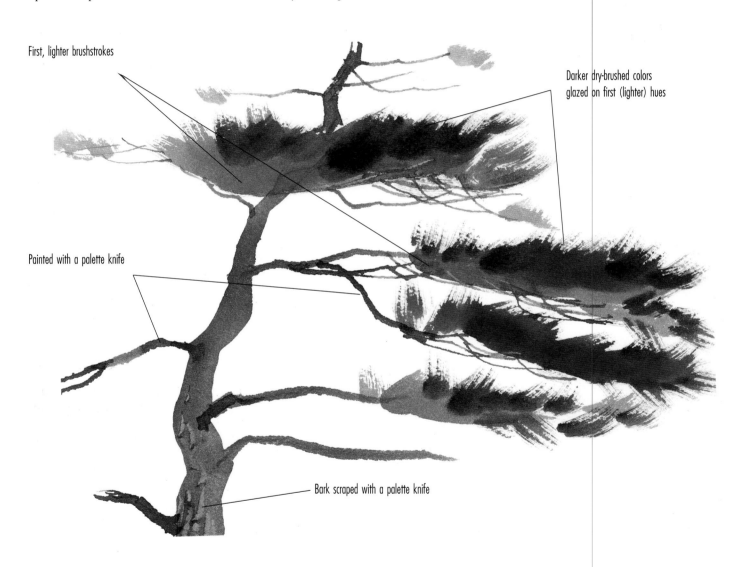

First, lighter brushstrokes

Darker dry-brushed colors glazed on first (lighter) hues

Painted with a palette knife

Bark scraped with a palette knife

The artist painted the branches with a palette knife, using liquid-consistency paint. The foliage was dry-brushed with a 2-inch (51mm) slant-bristle brush filled with dark paint. The colors were Gold Ochre, Magenta, Phthalo Green and Ultramarine Blue Deep.

Lifted White Trees

The high clarity of the white trees is the direct result of the artist's choice of an efficient tool: a nail clipper. The tip of its handle is very firm but smooth, so it won't tear the wet paper. Avoid ripping the surface by choosing a smooth tool that allows you to press very hard.

Any thin, light lines against a dark background can be done with this technique. Frosty weeds, birch, aspen or sycamore branches, or an older man's white whiskers are just a few examples. Think of techniques as principles—not isolated subjects.

Dark background to show strong contrast.

Scraped out with the smooth tip of a nail clipper handle

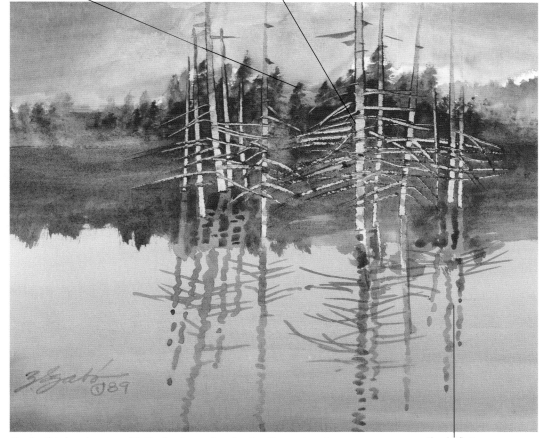

This group of bleached-out light trees is formed by scraping them out of a very dark and still-damp background with the handle of a nail clipper. Hold it between your thumb and fingers and press as hard as you can, with the strength coming from your wrist. Scrape the thin shapes with rapid strokes before the background has a chance to dry too much.

The same effect may be achieved by holding a small pocketknife blade on its side and guiding it with your index finger, removing the light shapes with heavy pressure.

Glazed reflections

Begin this landscape with the basic washes for the sky and water. The colors are Cyanine Blue, Gold Ochre and Rose Madder. With the same colors in rich, creamy consistency, quickly wash in the warm-dominated distant shore trees and their reflections using a 2-inch (51mm) slant-bristle brush. While this shape is still quite wet, press very hard with the tip of a nail clipper handle to remove the shapes of the light trees and their branches. Finish on the dry surface by painting the wiggly reflections with a rigger brush.

Flowering Trees

Here is a quick wet-into-wet technique. The dark background is painted first on wet paper, leaving the soft main shape (in this case, the flowering tree) as a negative shape. For this or any similar subject, make sure that the negative shape stays perfectly white while you paint the dark color around it. Use less water in your brush than there is on the paper. To get the soft mauve color, the flowering tree has to be painted on clean white paper.

Wet-into-wet shapes with independent-color dominance

Negative shape surrounded by darker wet shapes

Lines painted with a rigger brush

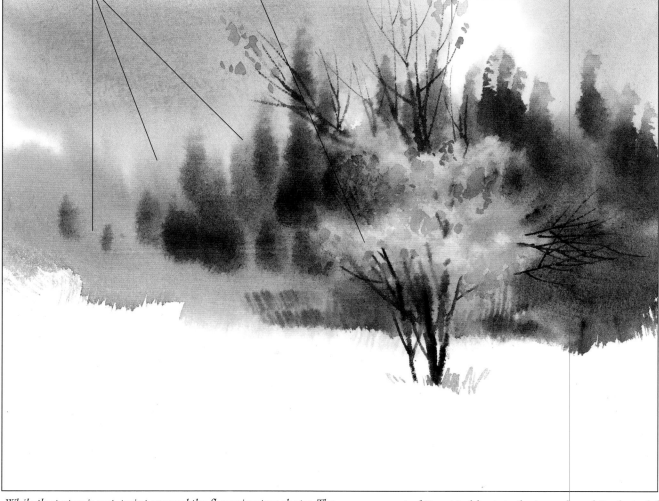

While the paper is wet, paint around the flowering tree shape. The sky is Cyanine Blue and Phthalo Green. For the gray at the left, add a little Rose Madder and Gamboge Yellow. Paint the dark evergreens Phthalo Green, Gamboge Yellow and Rose Madder. As the surface loses its shine, drop little rosettes of water and a small amount of Rose Madder into the irregular white shape left for the flowering foliage using a no. 5 rigger brush. The trunks and the branches are added when the paper is almost dry. Surround the flowers with the darkest colors to exaggerate the contrast.

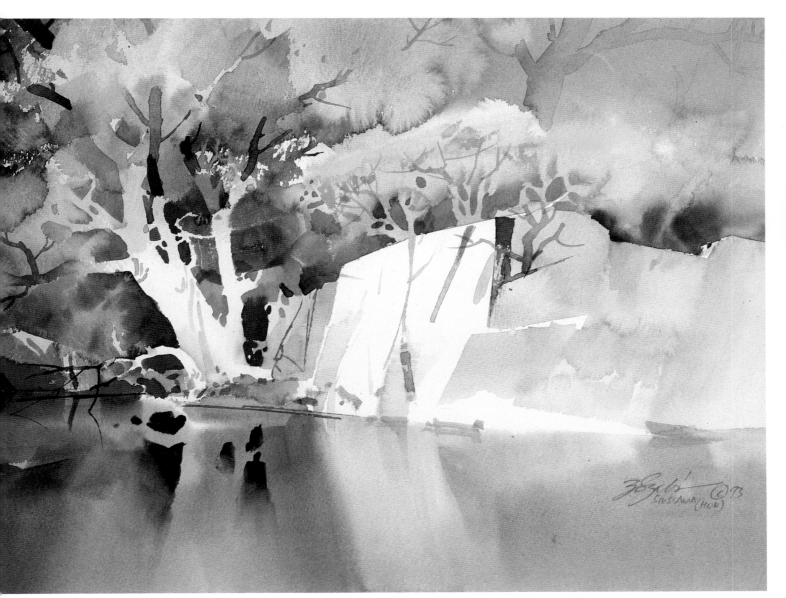

In this painting the dominant strength of white surrounded with rich, dark values and colorful shapes creates a powerful focal point. Starting on dry paper, carefully paint around the white network of rocks and the big white tree. Paint the foliage and the background with several colorful glazes, allowing some of them to create loose backruns to suggest clusters of foliage. Darks evolve gradually next to the whites to emphasize their brilliance. After all the images are finished, paint the water and the reflections in medium value, with a few dark accents where the contrasting focal point needs it.

Happy Glow
15" × 20" (38.1cm × 50.8cm)
Zoltan Szabo
Collection of Willa McNeill.

Brush-Handle Trees

For this technique, use a brush with a handle that has a slanted acrylic tip. For a larger painting, try using another firm tool, such as a credit card. The important thing is to watch the condition of your wet color: Don't use it too wet or too dry. If you use a 300-lb. (640g/m²) paper for a larger painting, it will stay moist a little longer, giving you additional time to maneuver a more complex design with this lifting method. For narrow shapes, use the slanted tip of your plastic brush handle.

Use Gold Ochre, Magenta and Phthalo Green. On thoroughly wet paper, brush in the tone and silhouette of the forest with a 2-inch (51mm) slant-bristle brush filled with lots of paint and just a little water. Where individual dark trees appear, use only the tip of the brush. When you stop painting, the paper should be barely moist—just right for scraping out the light trees. Hold the slanted tip of your acrylic brush handle slightly sideways for the widest tree, and then, with very firm pressure, scrape off the color. Even movement is essential for a successful shape. For the thinner branches, hold the brush handle at a higher angle. Because the ideal moist condition doesn't last long, timing is crucial. This scraping, for example, took only a few seconds. The dry-brushed grasses were applied for variety.

Scraped out from a damp color with the tip of the slanted end of an acrylic brush handle

Soft Lifted Trees

This lifting technique is a lot of fun. The ideal condition of the paper is between very wet and dry. For the dark, soft shapes, use much less water in the brush than there is on the paper. For the light shapes, a controlled, small amount of clear water in a small brush, painted into the damp color, provides a very exciting result. If you should be a little late and the water is not spreading, let it sit for a half a minute to loosen the pigment, and then blot it by pressing a tissue over the shape. Chances are, you will get your light lines anyway.

Color-charged medium-dark background

Clear water strokes painted into drying damp background

Dark lines painted into damp color

After wetting the paper completely, paint the dark tones of the forest with a rich mix of Burnt Sienna and Cobalt Blue. After the larger shapes look good, paint the ground with a Gold Ochre dominance in a rich wash made from all three colors. At this point, mix a very dark combination of Burnt Sienna and Cobalt Blue—dominated by Burnt Sienna— and paint the darker trees with the tip of the brush. As the wash loses its shine, lift out the wide, lighter tree with a ¾-inch (19mm) flat, damp but thirsty, aquarelle brush. Then switch to a no. 5 rigger and define the light trees and branches by introducing a little water from the tip of a rapidly moving brush. While wet, sketch in the blurry but clearly readable young trees in the center region with a rich mixture of blue-gray in your rigger.

Background Forest

This technique can be used for many background situations. Its success depends on decisiveness. Start off the shape with a very wet, neutral color, establishing the shape's value. Into this wet wash, charge brighter, lighter colors, and let them mingle freely: *Don't help them!* The fresh result is your reward for this discipline.

It takes a practiced sense of timing to create this effect. With the corner of a ¾-inch (19mm) flat brush, place a few droplets of water into the drying, but still moist, dark background color. The free shapes of the resulting backruns create exciting light impressions that look like frosty shrubs. There's about a 30 second time window, just as the drying paper loses its shine, when this technique works: Bad timing gives a bad outcome.

Backruns caused by water dropped into the drying color

Shapes united in value and varied by charged colors

Dry-brushed twigs created with a slant-bristle brush

Lines painted with a rigger brush

For this painting, use Magenta, Cyanine Blue and Cadmium Red-Orange. Paint the forest shape with a 1½-inch (38mm) slant-bristle brush, aggressively changing color dominance, by dipping into your palette and expanding your wash from left to right. Allow the left side to remain darker and bluer, turning lighter and warmer on the right. Before the color dries, place a few drops of water at the bottom edge of the wash to indicate frosty shrubs, and paint in the light blue to indicate icy snow. Total time to this point should be about two minutes. After most areas are dry, use a rigger brush to paint the tall trees that are in the foreground.

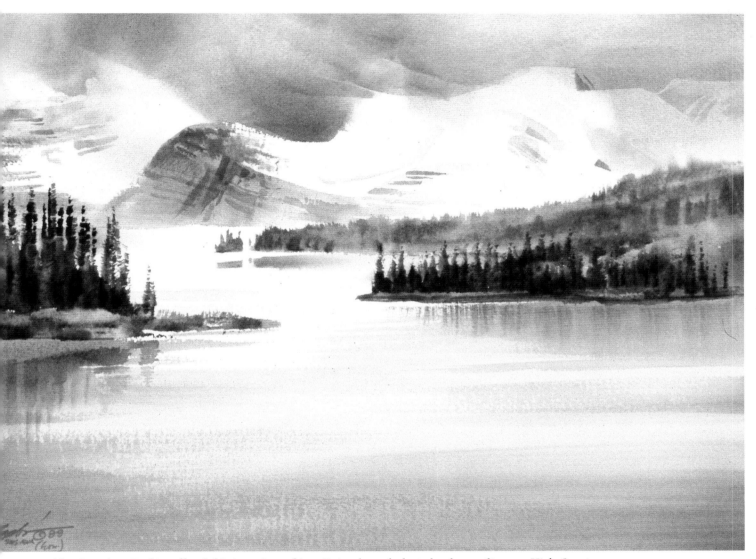

The Canadian Rockies offered this imposing subject. Paint the turbulent clouds wrestling with the snow-covered mountains in the background fast enough to allow some of the washes to wet-blend as they touch. The bright light in the distance justifies painting the mountains in warm colors. The middle-ground trees are dominated by dark values. Paint them with the edge of a slant-bristle brush held upright. The water in front is medium-value turquoise, a color typical of silt-influenced lakes of the Rockies. Paint the breezy surface with horizontal brushstrokes fast enough to blend, but here and there allow a little dry-brush to become part of the active water's surface.

High Country
14½" × 20" (36.8cm × 50.8cm)
Zoltan Szabo

Conifer Bark

Trees in the evergreen family tend to have heavily textured bark. The old-timers sport deep creases and plate-like folds that are perfect to sketch in pen and ink.

The conifers on this page were rendered in India ink and then tinted with watercolor.

Spruce Burl

Crosshatching

Scribble

Douglas Fir

Scribble lines

Salt-technique patterns suggest moss.

Spatter

Cedar

Wavy lines

Sugar Pine

Scribbly wavy lines

Hardwood Bark

The broadleaf, deciduous trees vary greatly in bark color and texture: The barks of some species change significantly with age. Don't hesitate to try out various technique mixtures.

Vine Maple Sapling

Textured with Payne's Gray, pen work, then tinted with watercolor washes.

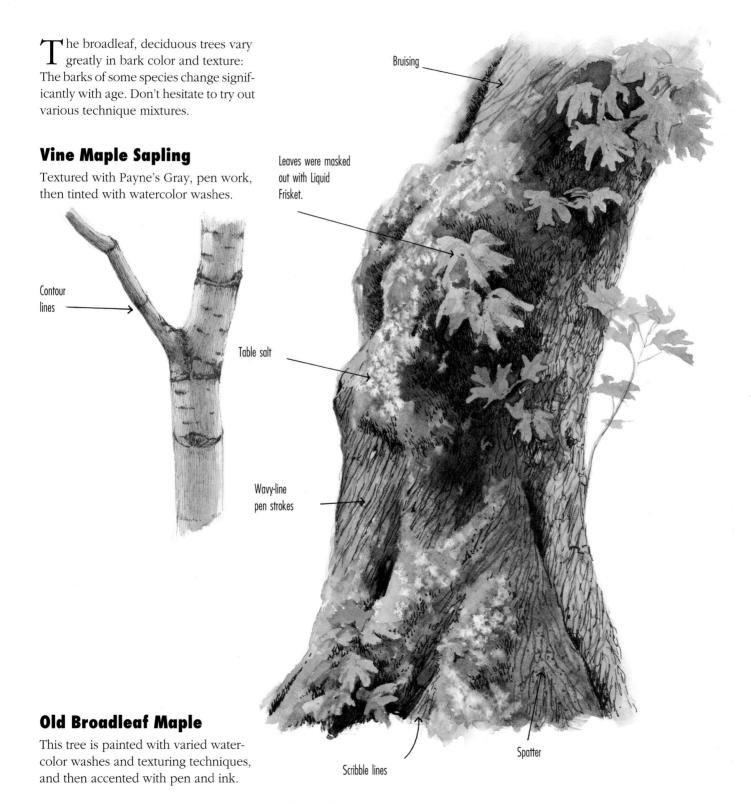

Contour lines

Bruising

Leaves were masked out with Liquid Frisket.

Table salt

Wavy-line pen strokes

Scribble lines

Spatter

Old Broadleaf Maple

This tree is painted with varied watercolor washes and texturing techniques, and then accented with pen and ink.

Miscellaneous Tree Bark

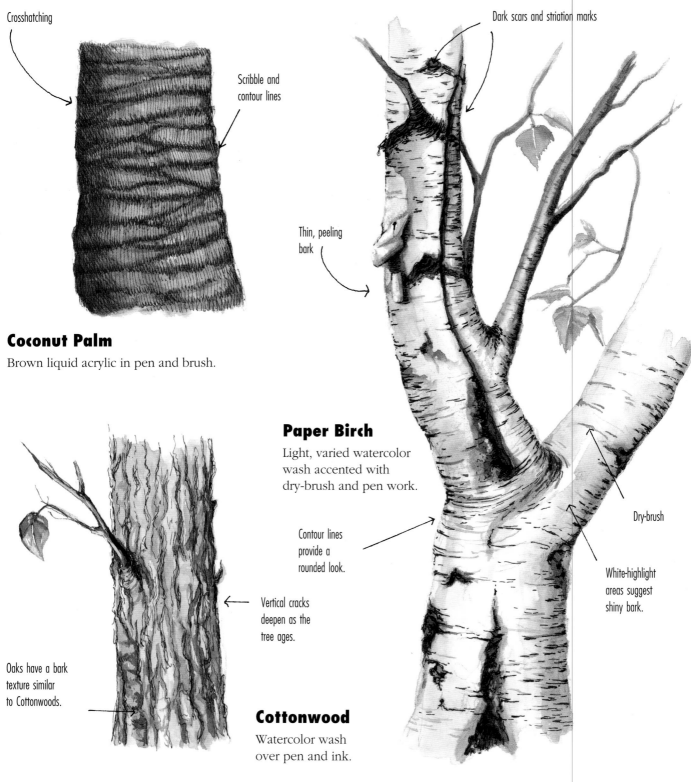

Crosshatching

Scribble and contour lines

Dark scars and striation marks

Thin, peeling bark

Coconut Palm

Brown liquid acrylic in pen and brush.

Paper Birch

Light, varied watercolor wash accented with dry-brush and pen work.

Contour lines provide a rounded look.

Dry-brush

Vertical cracks deepen as the tree ages.

White-highlight areas suggest shiny bark.

Oaks have a bark texture similar to Cottonwoods.

Cottonwood

Watercolor wash over pen and ink.

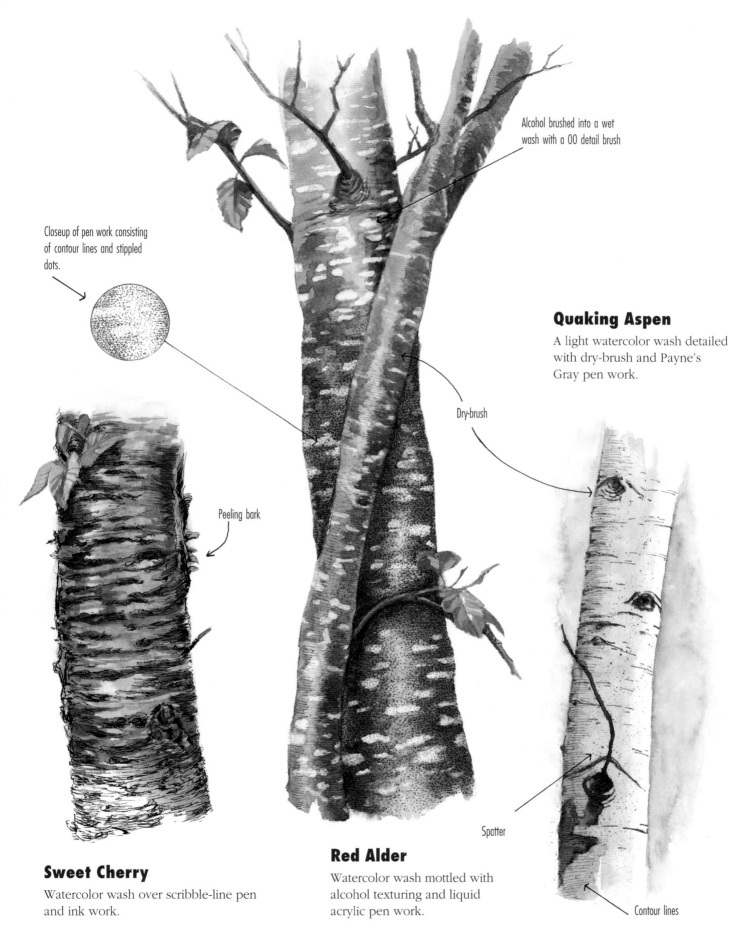

Closeup of pen work consisting of contour lines and stippled dots.

Alcohol brushed into a wet wash with a 00 detail brush

Quaking Aspen

A light watercolor wash detailed with dry-brush and Payne's Gray pen work.

Dry-brush

Peeling bark

Sweet Cherry

Watercolor wash over scribble-line pen and ink work.

Red Alder

Watercolor wash mottled with alcohol texturing and liquid acrylic pen work.

Spatter

Contour lines

Roots and Stumps

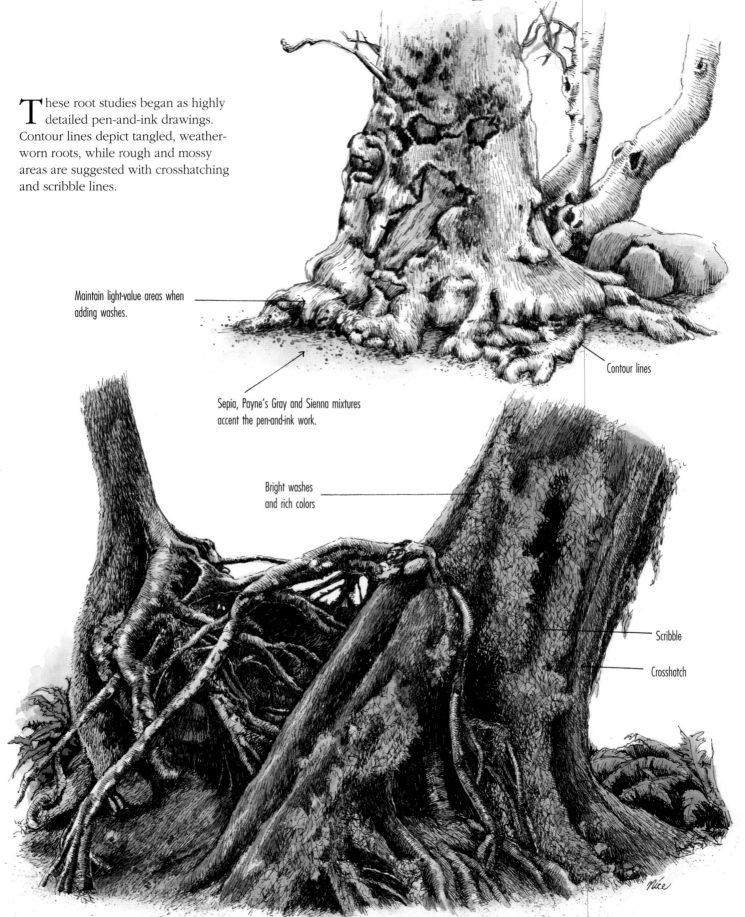

These root studies began as highly detailed pen-and-ink drawings. Contour lines depict tangled, weatherworn roots, while rough and mossy areas are suggested with crosshatching and scribble lines.

Maintain light-value areas when adding washes.

Sepia, Payne's Gray and Sienna mixtures accent the pen-and-ink work.

Contour lines

Bright washes and rich colors

Scribble

Crosshatch

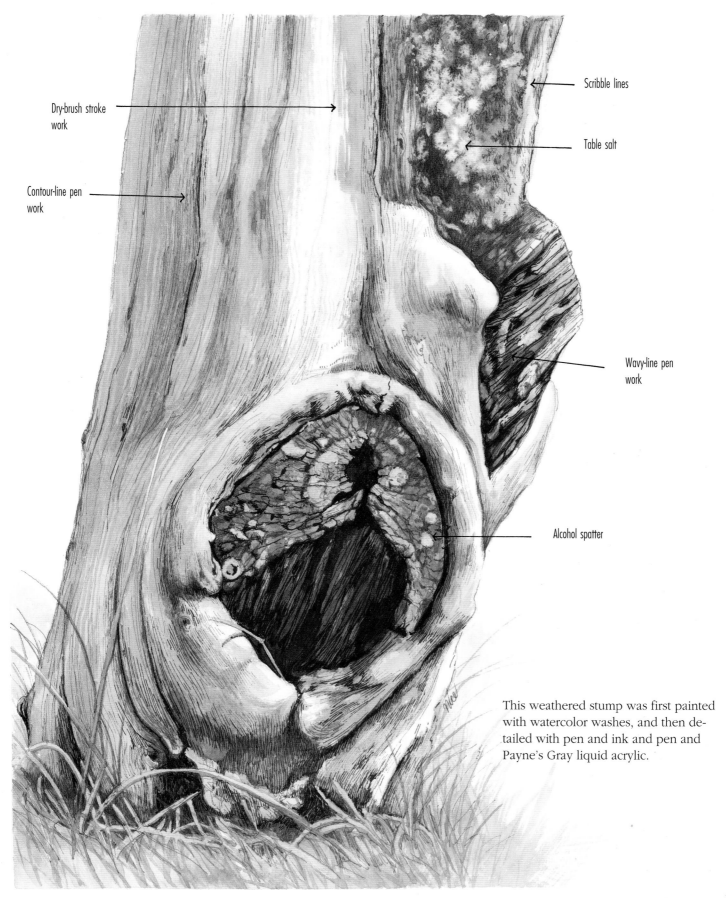

Dry-brush stroke work

Contour-line pen work

Scribble lines

Table salt

Wavy-line pen work

Alcohol spatter

This weathered stump was first painted with watercolor washes, and then detailed with pen and ink and pen and Payne's Gray liquid acrylic.

Branches

Winter is the best time to study the shapes and textures of tree branches. Ice, painted like clear glass, can add contrast and textural variety to the sketch.

The background of this winter scene is painted wet-on-wet, and then overlaid with parallel-line ink work in Payne's Gray liquid acrylic.

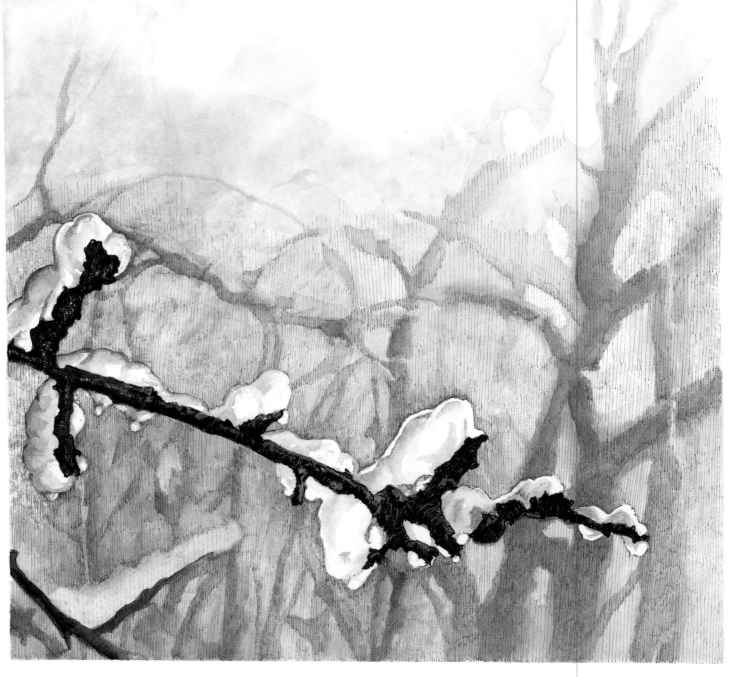

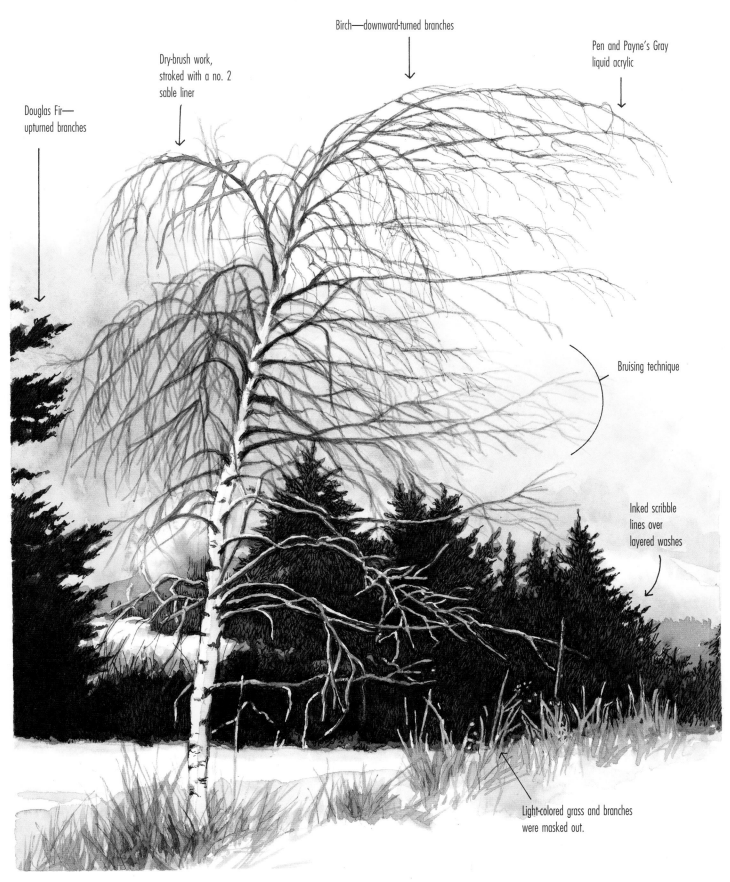

Birch—downward-turned branches

Pen and Payne's Gray
liquid acrylic

Dry-brush work,
stroked with a no. 2
sable liner

Douglas Fir—
upturned branches

Bruising technique

Inked scribble
lines over
layered washes

Light-colored grass and branches
were masked out.

Foliage: Ink Sketching

Brown liquid acrylic

1. Pencil in a grouping of varied, loosely drawn leaf shapes.
2. Ink around each leaf with a fine outline.
3. Shade in the background to "pop out" the leaves.
4. Add a little shade work to the leaves themselves. Parallel lines work nicely.
5. Tint the sketch with washes of watercolor.

Brown liquid acrylic

India ink

This technique works well to depict areas of dense underbrush and shrubbery.

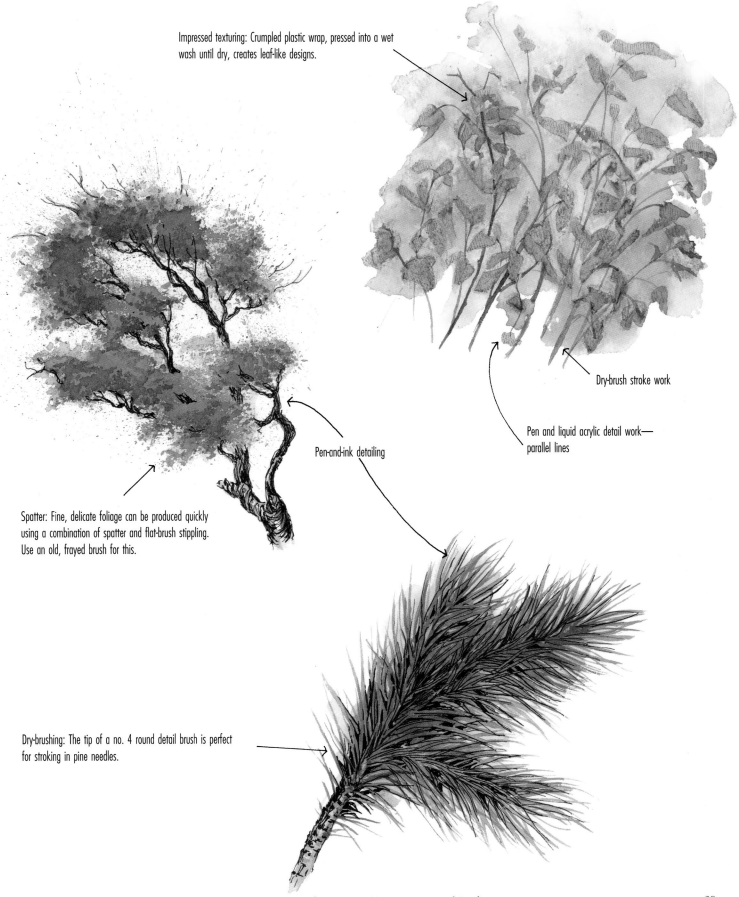

Impressed texturing: Crumpled plastic wrap, pressed into a wet wash until dry, creates leaf-like designs.

Dry-brush stroke work

Pen and liquid acrylic detail work— parallel lines

Pen-and-ink detailing

Spatter: Fine, delicate foliage can be produced quickly using a combination of spatter and flat-brush stippling. Use an old, frayed brush for this.

Dry-brushing: The tip of a no. 4 round detail brush is perfect for stroking in pine needles.

Distant Trees

At a distance, individual leaves become less important than overall tree shape, texture and color. Value contrasts and limited detail work are still important. Sponge-stamping is one technique to use for distant foliage. Other techniques are shown on the opposite page.

Sponge-Stamped Foliage

Suggest the trunk shape with a damp surface wash.

Using a damp sea sponge brushed with pigment, stamp in the foliage layers, beginning with the lightest hue.

Use dry-brushing to detail the trunk and create branches.

Pen-and-ink detail work added

Other Techniques

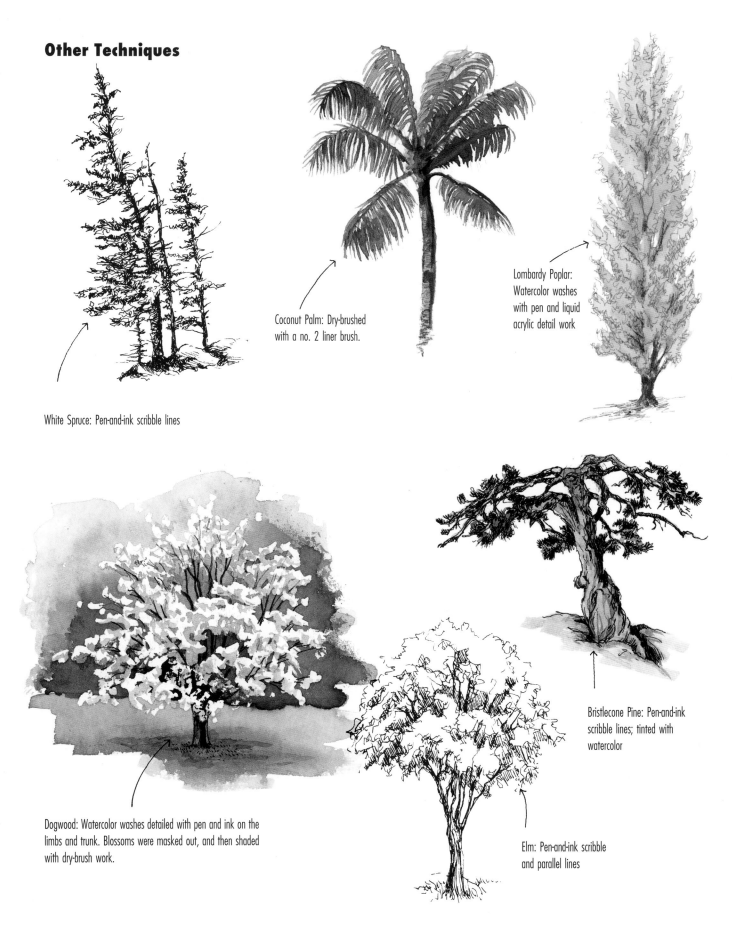

White Spruce: Pen-and-ink scribble lines

Coconut Palm: Dry-brushed with a no. 2 liner brush.

Lombardy Poplar: Watercolor washes with pen and liquid acrylic detail work

Dogwood: Watercolor washes detailed with pen and ink on the limbs and trunk. Blossoms were masked out, and then shaded with dry-brush work.

Bristlecone Pine: Pen-and-ink scribble lines; tinted with watercolor

Elm: Pen-and-ink scribble and parallel lines

Background Trees

As trees recede farther into the distance, texture is flattened, color is muted, and shape is merely suggested.

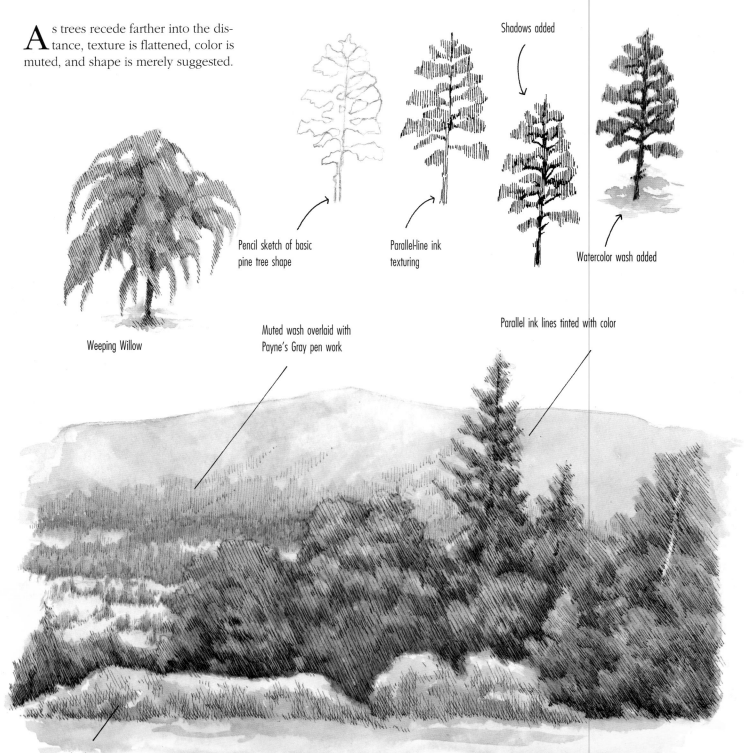

Shadows added

Pencil sketch of basic pine tree shape

Parallel-line ink texturing

Watercolor wash added

Weeping Willow

Muted wash overlaid with Payne's Gray pen work

Parallel ink lines tinted with color

Crosshatching

Background forest of mixed trees and shrubs

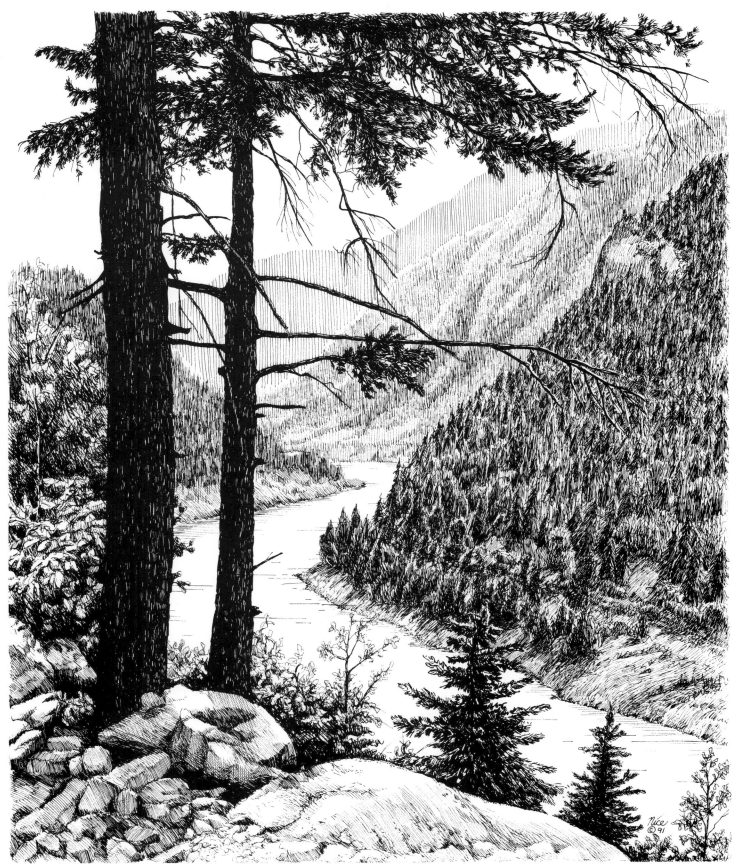

Note the difference between foreground and background textures and values in this pen-and-ink landscape. Rapidograph sizes 1, 3×0 and 4×0 were used.

A Place for Vision Quests
9" × 7¼" (22.9cm × 19cm)
Claudia Nice

Fall Foliage

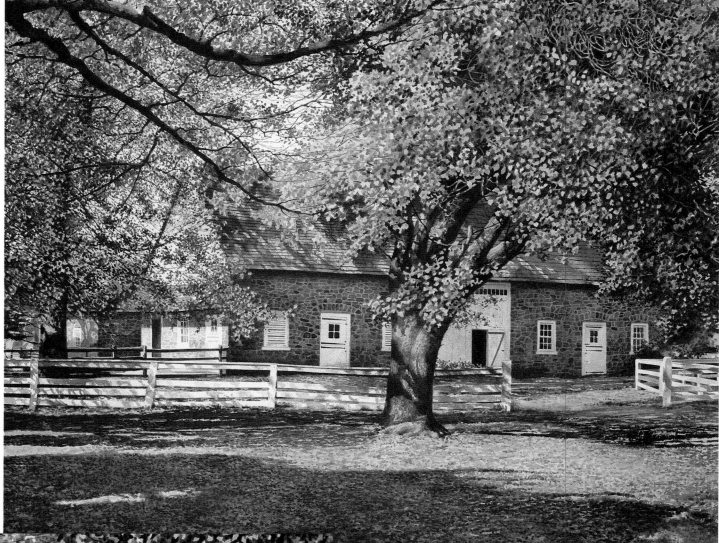

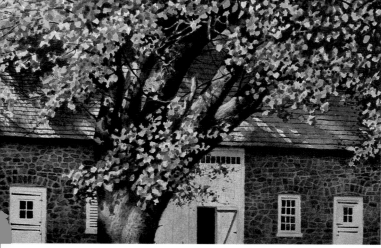

Situated in Bucks County, Pennsylvania, is Pennsbury Manor, the country home of William Penn. Completed in 1699, it included a vast estate of eight thousand acres. The house that stands there today is a re-creation of the seventeenth-century home. The beautiful fall foliage of the magnificent tree is what Rocco wanted to capture.
Autumn at Pennsbury
17" × 23" (43.2cm × 58.4cm)
Michael P. Rocco

Detail of Trees

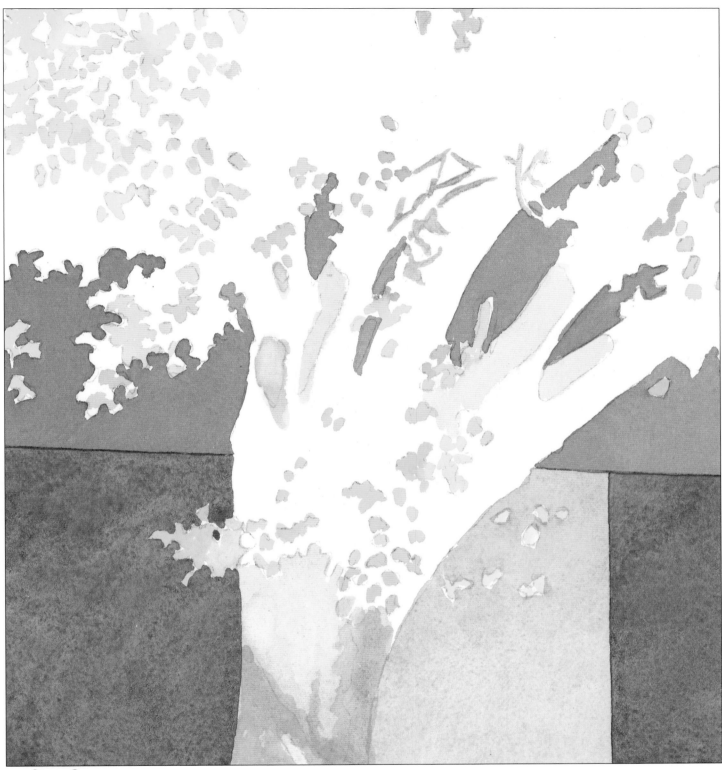

Step One

Draw the general shape of the tree, noting areas of the leaves and twigs that are to receive first colors. Paint the pale yellows, oranges and some bright greens of the foliage, and then add the color of the twigs and the sunlit portions of the branches.

Paint the trunk and, while the area is moist, blend color for soft shading. Let this all dry, and then paint the background to give contours and value relationships and to establish light on the trees.

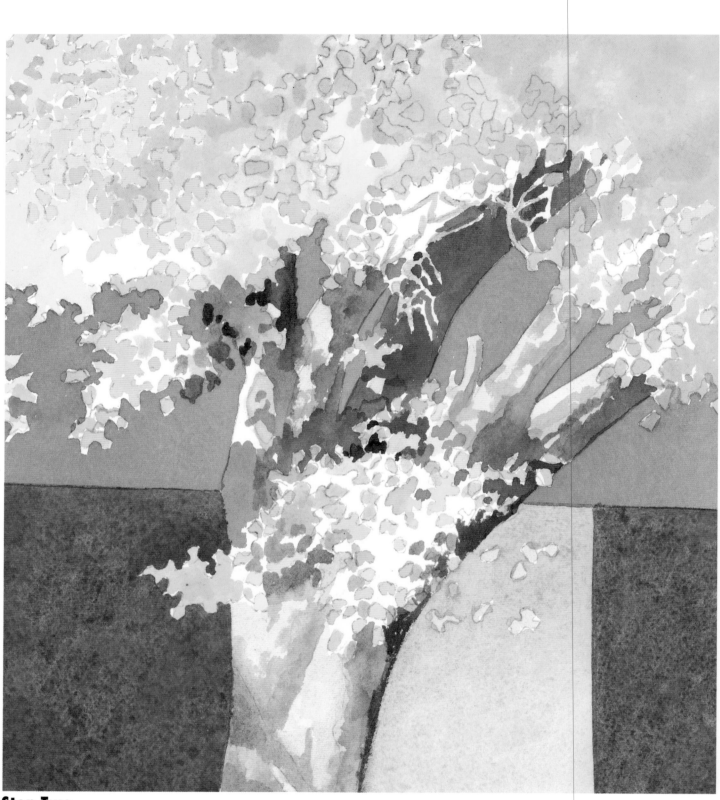

Step Two

With various shades of yellow-green, paint most of the foliage, working around previous colors. Once dry, add slightly deeper tones of green to the area and into the yellows to define shapes. Then paint the shadows on the branches, again working color to form twigs. This method of painting retains the transparency of color. Intensify some shadows for depth, and blend more color into the trunk.

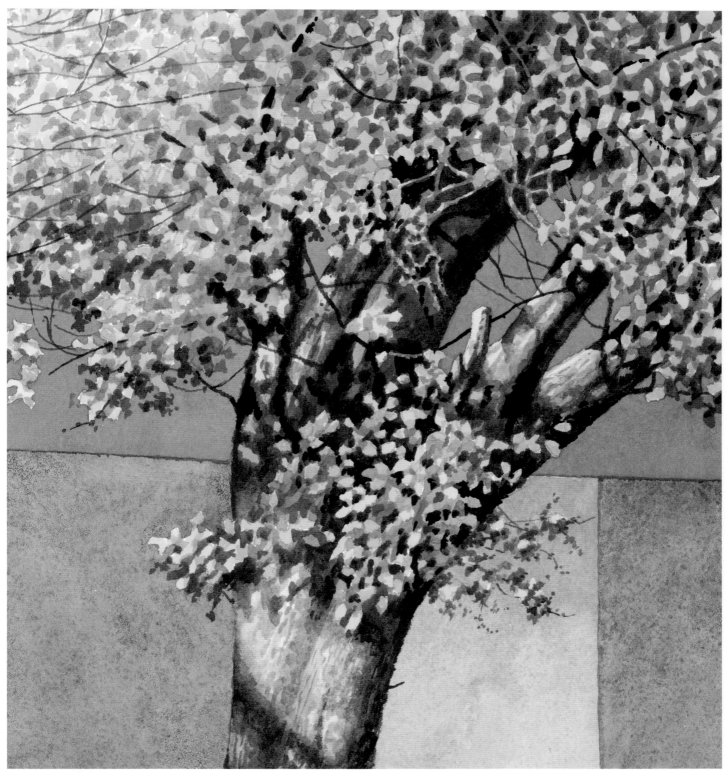

Step Three

Paint intermediate tones in various colors throughout the foliage, defining shapes. Strengthen some yellows and oranges, adding sienna and umber for shading. Apply washes of deeper tones for depth and, finally, add the dark accents. Dry-brush texture into the bark; form the branches and trunk with blends of color and shadow. Strengthen the shadow falling on the lower part of the trunk and fade its edges softly. Paint the dark, thin branches, and wash away color for additional twigs. The dark leaves painted in the background area add depth.

Bare Branches—Background First

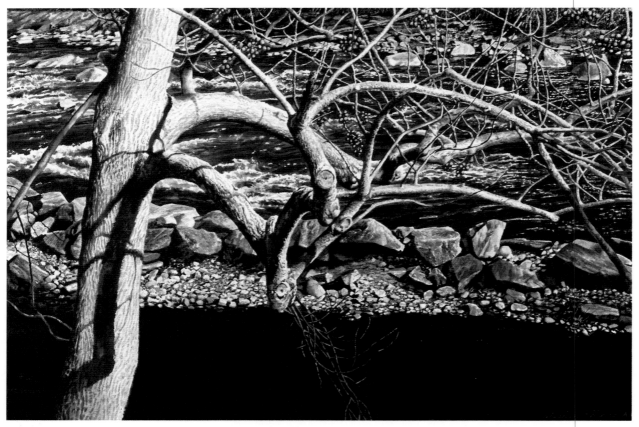

What a challenge—having to look through the weblike configuration of tree branches to paint the rushing water and everything else beyond them, yet hold the composition together! Rocco accomplished this by carefully drawing the tree, indicating branches that projected in front of others and the important details. All the compositional lines—the ragged distant shoreline, the foreground finger of land, and some rocks in the river—were loosely handled. Everything else was painted in as he progressed, without any drawing. The entire background was painted to completion before concentrating on the tree. An unorthodox way of painting—but it worked!

Along the Brandywine
14" × 21" (35.6cm × 53.3cm)
Michael P. Rocco

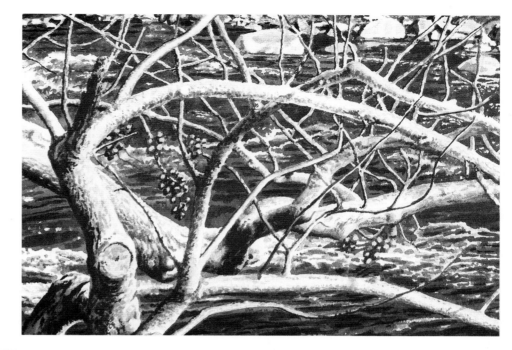

Detail of bare branches

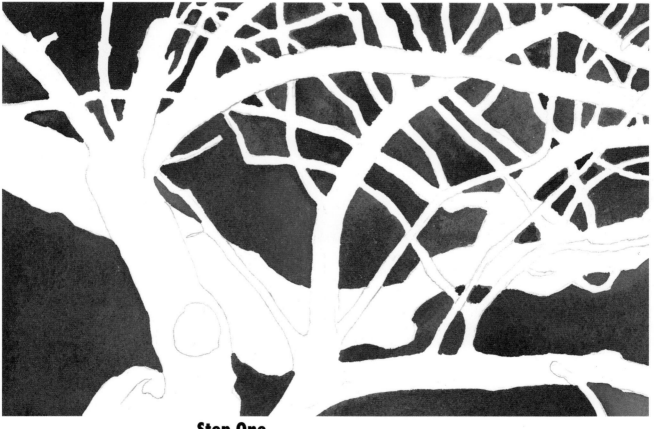

Step One

First, paint in a very simple background. Although the background is cut into small pieces, keep a continuity through it all. Ripples, foam and shadows should flow properly behind the branches, and each section should belong to an adjacent one.

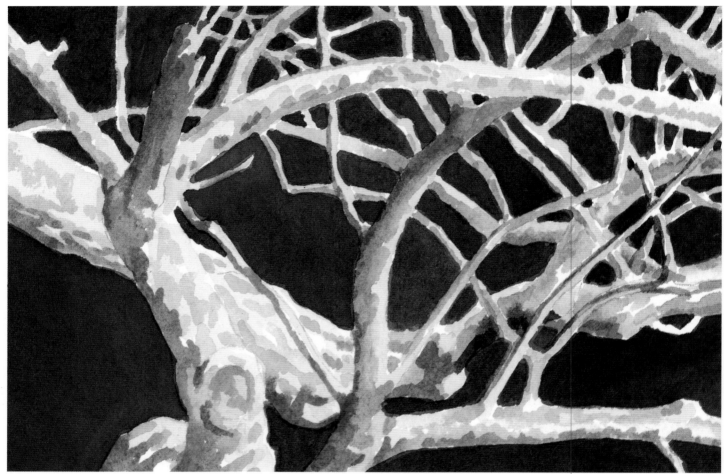

Step Two

Unscramble the myriad branches by painting the shadow sides of major branches first, which enables you to follow their paths. Also put in those sections that are completely in shadow and those that recede behind others. The values of your color should not be intense (think "reflected light" as you paint). Add various pale colors to all the branches, blending some areas in wet for softness of shading and to give form to the limbs. Once dry, indicate the bark with slightly deeper values.

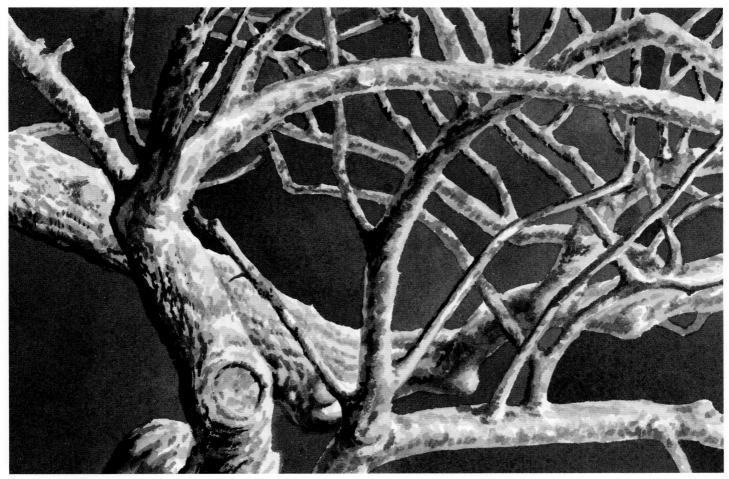

Step Three

Dry-brush more bark texture into all the branches, and then accent its shadows. Work on the main part of the trunk, dry-brushing texture, adding growth rings and strengthening shadows to amplify the feeling of light. Accentuate the knob—a small but important detail that focuses the eye away from the confusion. Intensify shadows where necessary to add depth and direction. Remember, branches grow out of branches, and should appear to do so in a painting. They are always thicker at their point of origin, just like the trunk growing up from the earth.

Apple Tree Leaves

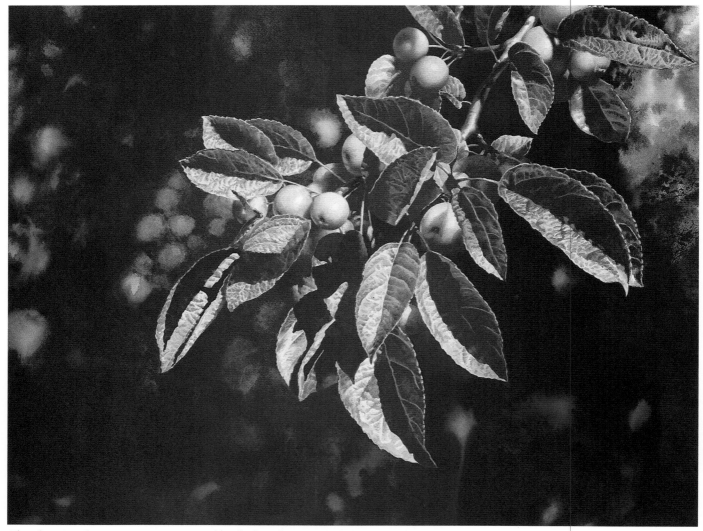

After drawing the composition, paint a thin dark outline around all the contours, and then paint the entire background in one effort. This immediately establishes contrast and brilliance. Some areas of the background are painted wet-into-wet; others are heavily pigmented. Keep the color flowing. Allow no section to dry with a hard edge. Use a no. 12 round brush and a 1-inch (25mm) flat brush for this broad area.

Apple Tree
18" × 23" (45.7cm × 58.4cm)
Michael P. Rocco

Basic Nature Painting Techniques in Watercolor

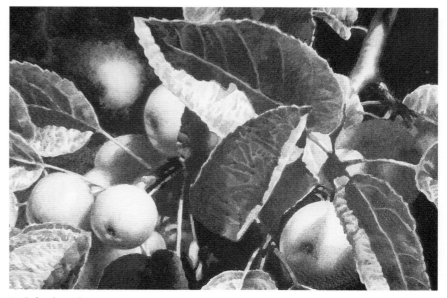

Detail of apple tree leaves

Step One

Starting with the upper leaf, paint the pale color in the lower half up to the central vein. Add the pale yellow to the edges of this leaf and the lower leaf, including the curl, and then blend the changes of color. Let this dry. Now paint the shadow of the upper leaf with variations of color to give a translucent quality. Paint around the central vein so that the shadow below it becomes more intense. Treat the body of the lower leaf in the same manner. Add color to a small leaf in the back. Put in a dark background to help establish contrasts.

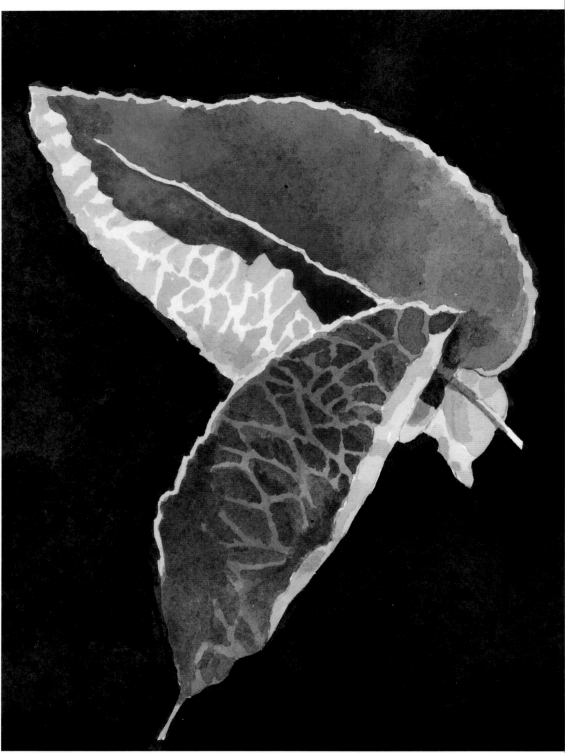

Step Two

Start developing the tufting of the leaves by overlaying spots of intermediate color on the lighter washes to form veins. In some areas where shadow obliterates the detail, this color is solid. Where the leaves overlap, add changes of value; add a shadow there and on the stem. With clean water, lighten a portion of the shadow on the upper leaf to increase the translucency. Then shade the small leaf.

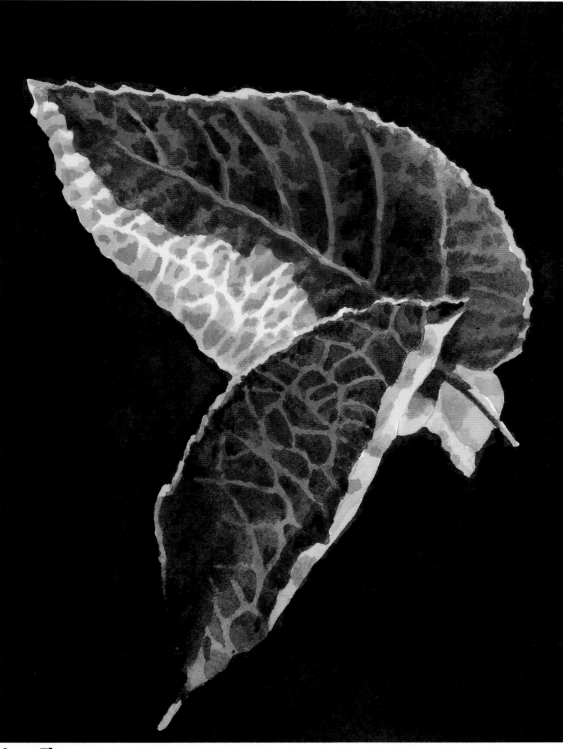

Step Three

Accentuate the tufts with deeper values, making the veins more obvious. Tone down the central vein off the upper leaf, and then clean away thin lines in its shadow to create tributaries. Form the tufts in the shadow with still deeper tones, and strengthen shadows in the lower leaf to emphasize its curl.

Tall Grass

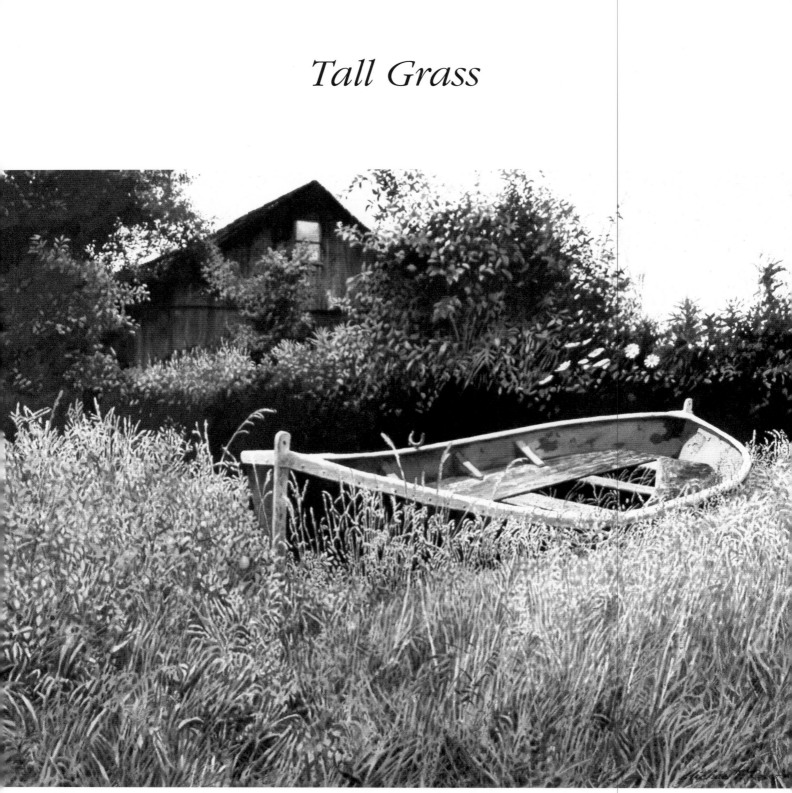

This painting is a composite of two scenes. The boat and the foreground, with its overgrowth of grass and weeds, are from one transparency; unfortunately, its background was flat and uninteresting. The artist made a thumbnail sketch of the proposed composition and then searched his slide file to find something suitable for the background. This is the advantage of having a reference file. It saves time; it recalls certain inspirations; and new excitement can be found in subjects that might otherwise have been overlooked.

Abandoned Boat
17" × 23" (43.2cm × 58.4cm)
Michael P. Rocco

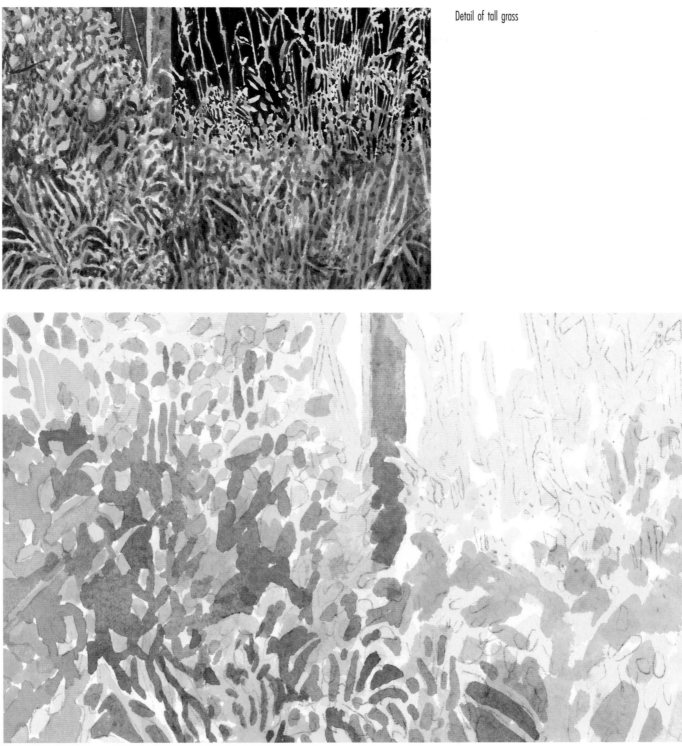

Detail of tall grass

Step One

Draw a minimal amount of detail in the foreground: the tall grasses, the general shadow areas and the prow of the boat. Everything else can be handled with brushwork. Begin by freely painting the pale yellows throughout, and follow this with the yellow-greens. To these, add patches of yellow ochres and pale olives, forming shapes within the first washes. With a deeper olive, paint shadow areas, developing additional shapes of leaves and stems. Put in the prow of the boat, giving the front board thickness.

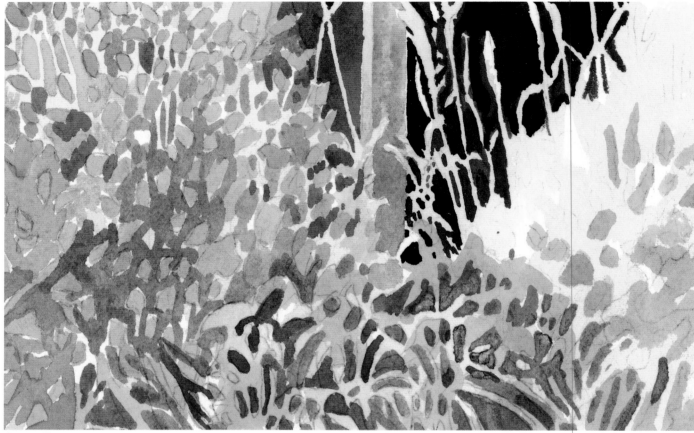

Step Two

To form the sunlit grass, put in a section of the boat, painting the dark color into the pale yellow wash around the stems and leaves. Paint the other side of the boat using the same technique. Continue to add deeper colors, forming more shapes. You don't need to do a tight rendering that shows every blade of grass to capture the feel of dense, tangled undergrowth.

Step Three

Detail the tall grasses with yellow ochres and Raw Umber to bring forth the sunlight. Finish the formation of the grasses by painting the dark of the boat, bringing this color down to a point where the shadows of the leaves and grass take over. Wash away some color and accentuate shadows on and under leaves to enhance the feeling of light and form. Finish with the darks of the undergrowth, which add to its dense look.

Weeds

To paint this colorful clump of weeds, first wash in the neutral background color. The initial silhouette of the weed clump is painted on the dry white paper and into the still-damp wash at the top simultaneously. The edges will stay sharp on the dry surfaces but blur when they touch the moist color. If your dark color is rich enough and you apply the color very fast, the difference will be negligible. The scraped-out weeds look colorful because the dark color behind them is dominated by separate charged colors; therefore, the light weeds show the dominant colors that are underneath them.

Light shapes have been scraped out with the handle of a nail clipper.

Dominant dark color dominates lifted light colors, too.

Dark over damp gray is diffused.

Lost-and-found edge strokes

Using a 2-inch (51mm) slant-bristle brush, dry-brush Venetian Red and Gold Ochre shapes onto the dry (white) and damp (gray) paper, adding Ultramarine mixed with Venetian Red as a neutral dark complement. Immediately squeeze off the light weed shapes with the smooth tip of a nail clipper handle. Paint the snow with a ¾-inch (19mm) flat soft brush; lose its top edge with a thirsty 1-inch (25mm) slant-bristle brush.

Basic Nature Painting Techniques in Watercolor

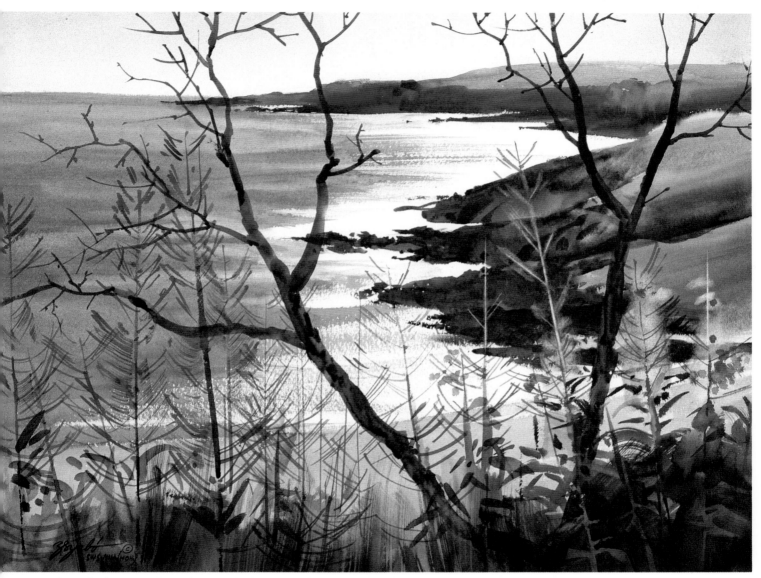

This calm but rugged coastline is a high-contrast background for the delicate fireweeds with their dark branches. Paint the sky, the coastal hills and their rocky shores first. Then glaze the middle-value sea on dry paper. Move your brush horizontally and lift it gradually as you approach the coastal rocks. The resulting dry-brush leads the eyes to the white shimmer. Over the lighter parts of this background, near the bottom, paint the colorful lace of the fireweeds; where they cross a dark area, lift off the background with a wet scrub-and-blot technique. Glaze leaves of the weeds with dark glazes, and finish the painting with the dark tree and its fine branches.

Scottish Autumn
13½" × 17½" (34.3cm × 43.2cm)
Zoltan Szabo

Clumpy Earth

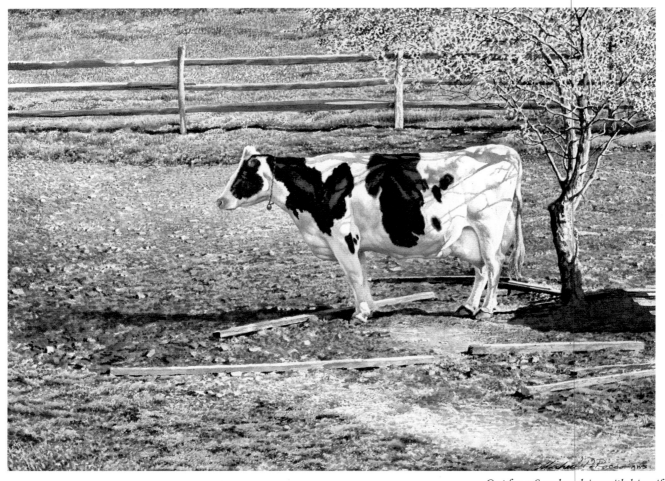

Out for a Sunday drive with his wife—and a camera—Rocco came upon this cow standing away from the rest of a small herd. It was a warm day, so the cow turned its back to the sun and stood in the meager shade of the sparse tree. All it had to do was go back into the barn for complete shade!

Cow in Lancaster County
17" × 23" (43.2cm × 58.4cm)
Michael P. Rocco

Detail of clumpy earth

Step One

Draw the image lightly on the watercolor sheet, and then mix a wash of a pale-red clay color and paint the entire field, working around the wood and patches of grass. Let the wash dry. Give the wood basic light colors; fill the grass areas with bright yellow-green. With a second wash of a slightly deeper value, go over the field, leaving areas of the first wash showing to form clumps of earth.

Step Two

Paint a third wash of still deeper value in the field above the lower board, again leaving some areas exposed to increase the effect of trodden soil. In the foreground, accent the clumps of earth and grass with light shadows. Indicate the cow's shadow across the field, giving the earth a feeling of solidity.

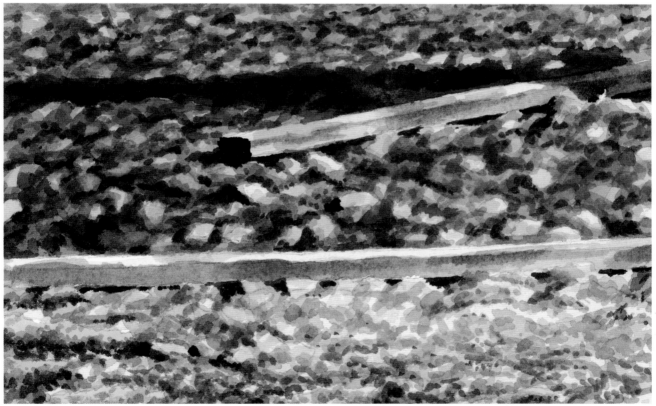

Step Three

In the upper field, deepen values in some areas, add shadows throughout, and accent with extreme darks to increase the feeling of light and dimension. Brush more texture into the foreground, and shadow the grass. Darken the shadow that falls across the field, but retain the inner light. Amplify the feeling of light by darkening the shadow's edge on the wood.

Stone

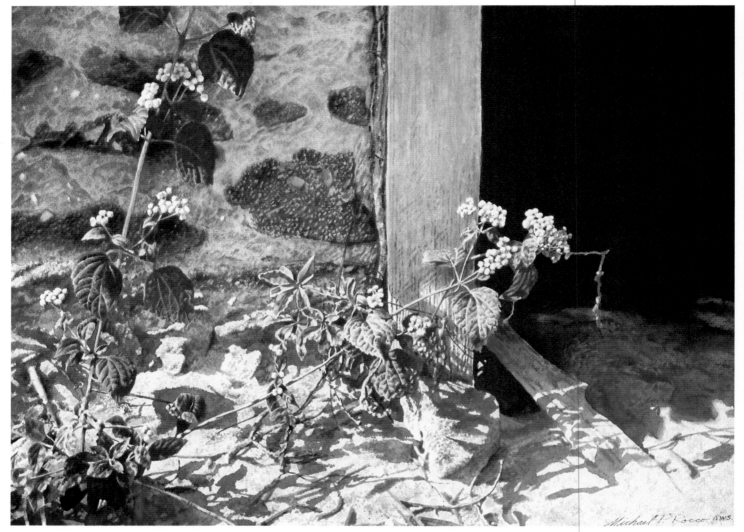

This challenging subject can be handled with proper planning and a simplified procedure. First, lay in the sandy earth tones, painting around all the stems and leaves. Next, add the warm gray of the stone wall, followed by the color of the wood beam. Paint the shadows on the ground and, finally, add the extreme dark of the open doorway. In this manner, you fill the sheet with patterns, color and values—and establish the drama—without getting into too many details.

Late Spring
18" × 23" (45.7cm × 58.4cm)
Michael P. Rocco

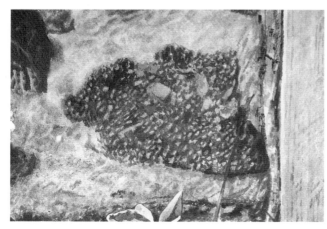

Detail of stone

Step One

Paint the mortar around the stone, adding color changes while the area is still damp and cleaning away some color where light is hitting protrusions. This particular stone contains numerous shapes of different colors. Cover other areas with pale washes; soften the edges at the top of the stone by scrubbing away color.

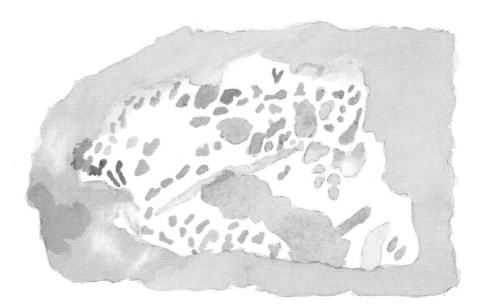

Step Two

Paint around all the color spots with second colors, leaving specks of clear paper for highlights and deepening areas that are in shadow, until you cover the entire stone. You can gain highlights from the first pale-blue wash by painting over this area with a deeper tone but leaving spots of the wash showing. Dry-brush texture and shadows into the mortar.

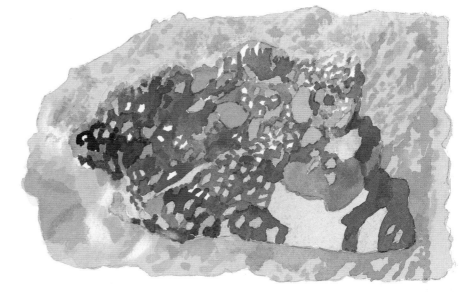

Step Three

Continue to add color to the stone, forming ridges and highlights and painting definite shadows. Tone down the original color shapes by shading them so that they become part of the stone. Deepen washes and complete them. Add further dry-brush texture and shadows to accent the irregular surface of the mortar.

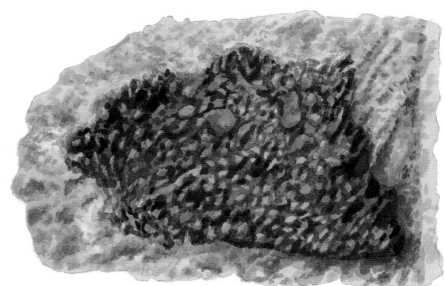

Sand

The fine particles of rock that make up seashores and desert dunes can be represented with damp surface washes textured with spatter and stippling.

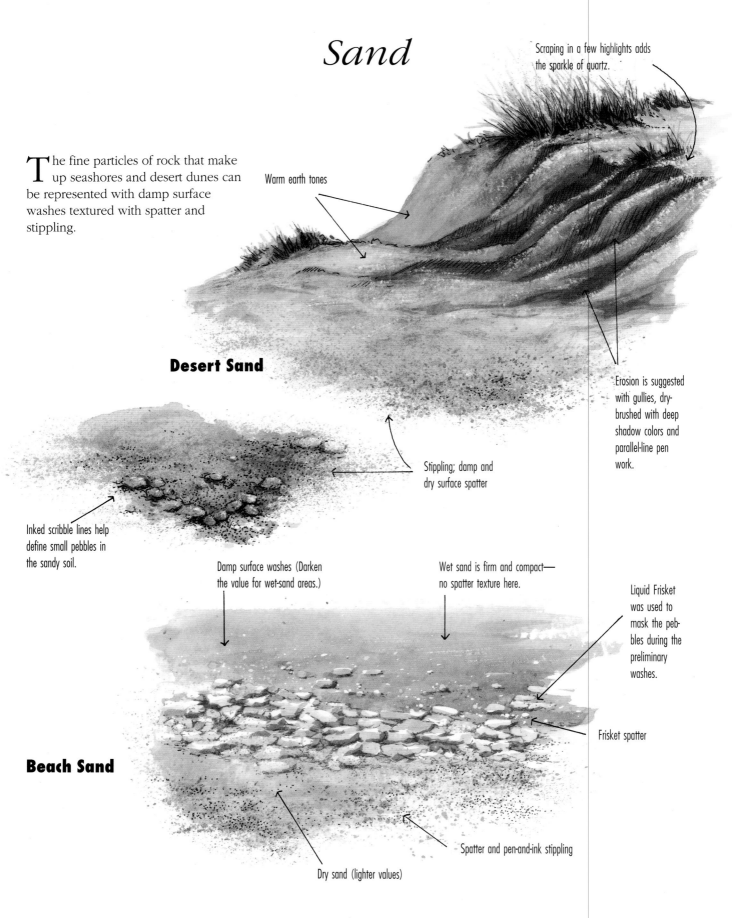

Scraping in a few highlights adds the sparkle of quartz.

Warm earth tones

Desert Sand

Erosion is suggested with gullies, drybrushed with deep shadow colors and parallel-line pen work.

Stippling; damp and dry surface spatter

Inked scribble lines help define small pebbles in the sandy soil.

Damp surface washes (Darken the value for wet-sand areas.)

Wet sand is firm and compact— no spatter texture here.

Liquid Frisket was used to mask the pebbles during the preliminary washes.

Frisket spatter

Beach Sand

Spatter and pen-and-ink stippling

Dry sand (lighter values)

Gravel

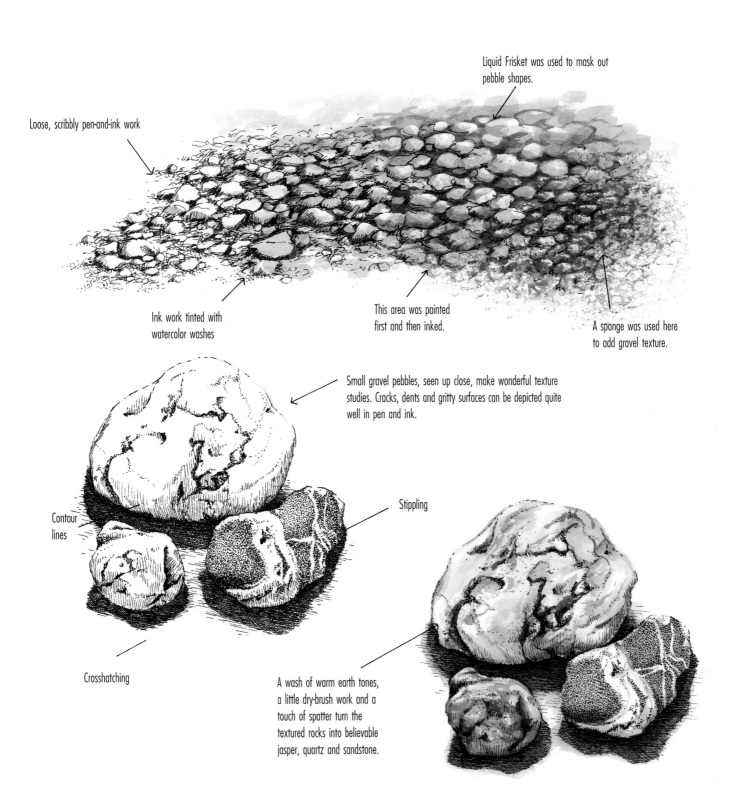

Liquid Frisket was used to mask out pebble shapes.

Loose, scribbly pen-and-ink work

Ink work tinted with watercolor washes

This area was painted first and then inked.

A sponge was used here to add gravel texture.

Small gravel pebbles, seen up close, make wonderful texture studies. Cracks, dents and gritty surfaces can be depicted quite well in pen and ink.

Stippling

Contour lines

Crosshatching

A wash of warm earth tones, a little dry-brush work and a touch of spatter turn the textured rocks into believable jasper, quartz and sandstone.

Painting the Light

This chapter provides an approach to designing paintings using lighted shapes and shaded shapes. Everyone who paints representationally relies on light: Without light you can't see—not the subject, nor even the paper you're working on. There is, however, a large difference between going out to paint *what* you see and going out to paint the *light* you see. Light has many characteristics: It can have color or be near-white; it can be direct or reflected; and it can be bright or dim.

Becoming aware of specific lighting conditions can make you a better painter. Before you begin to paint, take time to observe the color, intensity, direction and other qualities of the light. Ask yourself whether it's warm or cool, clear or hazy, direct (like a spotlight) or filtered (like a floodlight). One trick to identifying color is to look at colors with your peripheral vision. Know that every color in nature is reflected onto every other color: A clear blue sky should be evident not only in the sky but throughout the entire landscape. Being sensitive to light will not only help you paint, but will turn on a whole new world of color that will enrich your life—and make you the envy of those not so blessed. And then, when the inevitable question is asked, "Do you see those colors?" you can raise your eyebrows, look the questioner in the eyes and respond, "Don't you?"

William B. Lawrence

Spotlight

Too often, less experienced painters, when painting on location, use the spotlight approach. Each object is defined by its light side, shadow side and cast shadow. There is much to-do concerning where the sun is and how it describes form. The problem with this approach is that the resulting painting places too much emphasis on isolated objects and not enough on the overall patterns created by a single light source—the sun. You have to remember the sun is ninety-three million miles away. It illuminates the entire atmosphere of half the Earth, and is not directed, like a theater spotlight, at individual objects.

We perceive objects as spotlighted on days when the atmosphere is crystal clear. On these days everything seems sharply focused and hard edges abound. Mountains ten miles away, a house fifty yards away, and the person you're talking to all have the same crisp, clear edge. It is essential on these days that you find the bridges—those edges of nearly the same value, color or texture—that will lock these shapes into the painting. Cast shadows often provide the connections you need: Look for shadows that link darks together.

You should design and paint the pattern of light and shade on beautiful sunny days, and forget the object-by-object description of form.

◄ *There are days, sometimes many in a row, when fog lies along the Maine coast and transforms colors, values and textures into a symphony of softness. Subtlety is the key word on these days.*
Light at Pemaquid Point
20" × 26" (50.8cm × 66cm)
Skip Lawrence

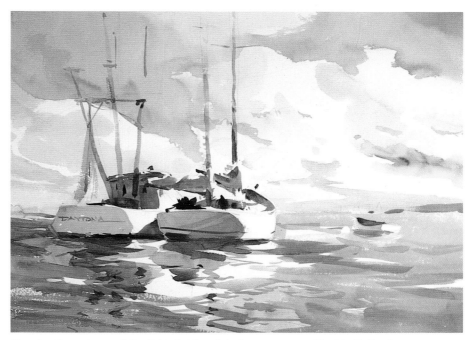

The sky, the water and the lighted sides of the boats are kept close enough in value to make all three areas read as a unified expression of sunlight. The shade is the right size, shape and value to convey the effects of clear light.

Florida Reflections
22" × 30" (55.9cm × 76.2cm)
Skip Lawrence

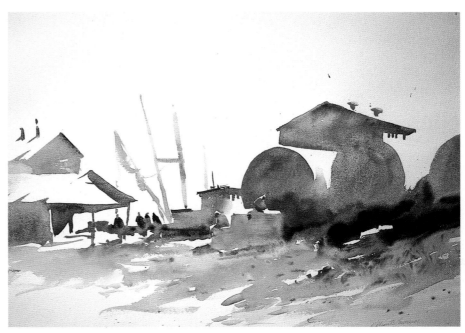

When the sun is bright and the atmosphere is clear, value contrasts are strong and edges are crisp. Instead of the tanks and buildings, see the beautiful pattern of light and shade.

Ft. Myers, FL
20" × 26" (50.8cm × 66cm)
Skip Lawrence

Floodlight

The quality of light from a floodlight differs from that of a spotlight in significant ways. The floodlight comes more from an overhead direction, produces softer edges and reduces value contrast.

When painting landscapes, compose with a floodlight in mind rather than a spotlight. Think of light as something created by the sun illuminating the earth's atmosphere, filtered and falling gently to the earth's surface, like snow. Except for those few hours of the day, at dawn and at dusk, when the sun is very low and the sides of objects are directly lit, this perception is both useful and accurate. The sun is a floodlight that illuminates an entire segment of the earth—not a spotlight that moves from house to tree to figure like the lighting in a stage performance.

By thinking of the sun as a floodlight, you'll benefit from different perceptions of light, which will improve your painting. The first of these is that floodlights produce a soft, filtered light that softens edges. Where edges are softened, the eye moves gently from shape to shape and from color to color. Razor-blade edges, the result of spotlighting, stop the eye's movement, isolating shapes and colors and giving the perception that the objects exist in a vacuum.

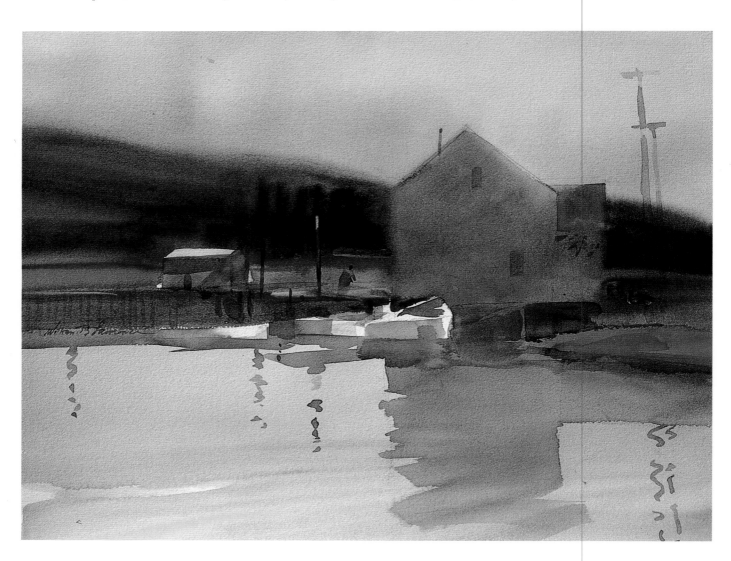

Basic Nature Painting Techniques in Watercolor

Soft, Filtered Light

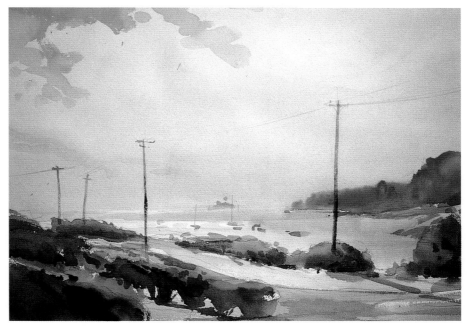

The white, hazy light of August creates a floodlight effect for this painting. As an alternative to creating atmospheric images that are the result of moisture, you can obscure distant shapes with light.

Long Cove
20" × 26" (50.8cm × 66cm)
Skip Lawrence

loodlighting is a softer filtered light that reduces value contrast. The truth is that all light is filtered. After all, the light of the sun has to travel through two hundred miles of the Earth's atmosphere. Artificial lights are not exempt from the effects of the billions and billions of molecules that make up our atmosphere. If you have difficulty seeing the effects of the atmosphere, imagine you are painting underwater. The Earth's atmosphere is nothing more than very thin water, so this approach often makes a difference.

An obvious example of the effects of atmosphere and of the floodlighting idea is a foggy day in Maine. Skip Lawrence once had a workshop group in Maine that had a chance to see firsthand how fog and filtered light—ten straight days of it—reduce value contrast and soften edges. For those who would like this opportunity, any two-week stay along the Maine coast will provide at least one day of rich, thick fog.

◄ *The effects of thinking* floodlight *rather than* spotlight *are significant. Edges are softer, value contrasts are closer, and color takes on a more important role. This painting was done from a photo taken on a sunny day. The spotlight effect of a sunny day was translated into a floodlight effect of a hazy day: Subtleties of value, color and texture contrasts predominate.*
South Bristol, ME
20" × 26" (50.8cm × 66cm)
Skip Lawrence
Collection of Alex Powers.

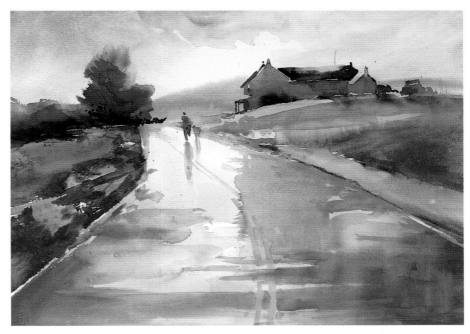

Take advantage of inclement weather. On such days you will find the beautiful effects of floodlighting. When else will you have the chance to see reflections on a road? Only with such soft, filtered light can you use bilious colors and have them look natural.

Mountaindale Road
20" × 26" (50.8cm × 66cm)
Skip Lawrence

Atmosphere and Contrast

You don't have to paint in fog to understand the effect of floodlighting on value contrast. Just remember that no matter how clear the day, you are always seeing everything through veils of illuminated atmosphere. Using this approach, you will recognize that it isn't possible to see the extreme values of white or black. When you reduce value contrasts, your paintings are filled with atmosphere, and color plays a much more important role. Even the subtlest colors suddenly become visible and exciting.

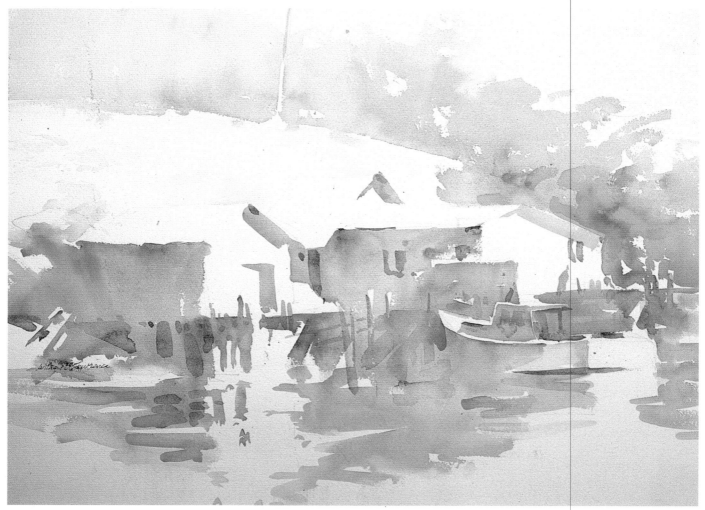

With floodlighting, value contrasts are close. Instead of the values changing from white to black, think of reducing the contrasts from white to slightly darker. The effect of these close value contrasts is a feeling of brilliant light that reflects off everything and keeps even the value of shadows light: Take care with lost edges, which help to give the impression of soft, filtered light.

Lobstermen's Coop
20" × 26" (50.8cm × 66cm)
Skip Lawrence

Basic Nature Painting Techniques in Watercolor

Light From Above

Another effect of floodlighting, or the idea of the sun illuminating the atmosphere, is that light appears to fall from above and settle on the tops of things. The best way to understand this idea is to think of light as snow. Where snow would collect is the same surface where light collects. Vertical planes don't hold the snow. The more horizontal the plane, the more snow accumulates and the lighter that surface appears: The same is true of light.

With this in mind, a lawn appears not as green grass but rather as a horizontal plane collecting light. The same is true of a black roof, a figure's shoulders or the rail of a boat. Vertical planes, which the snow (light) cannot collect on, retain more local color and appear darker in value. The shadow side of objects does not actually get darker, but only appears darker due to the contrast of being seen against the light. When there is strong light, what we identify as shadow is not darker than before the light was turned on, but actually a little lighter. So don't paint the lighted side of an object lighter and the shadow side darker than local color: Paint the lighted side *and* the darker side lighter.

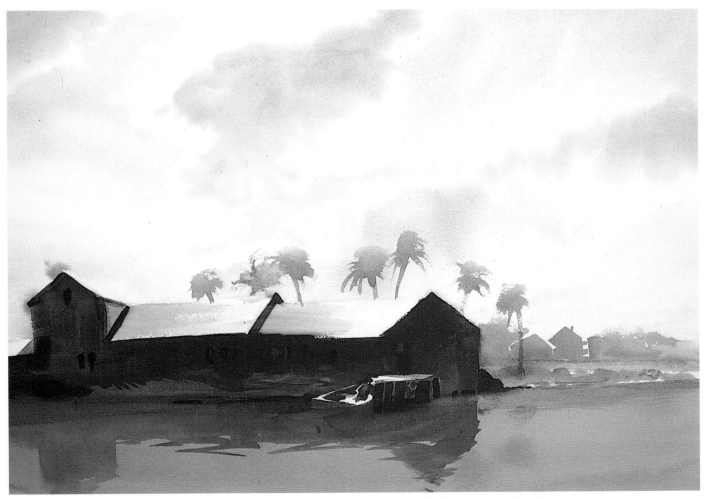

This collection of shacks illustrates the intensity of light—that intense light that falls from above like snow, obliterating the color of everything it falls on. In these cases, notice how the falling light affects the flat planes it settles on.

Florida White
20" × 26" (50.8cm × 66cm)
Skip Lawrence

Backlighting

The prospect of a subject lit from the back has the possibility of changing the entire mood of the painting. In *The Ficus Tree*, the backlighting places the viewer in the tree's shade, looking out to the light. By keeping the architectural structure understated, the pale values in the distance increase the dark contrast of the tree mass. This contrast sets up the hot, sunlit area and lets the texture, and especially the edges of the tree foliage, stay close, surrounding the viewer.

In *Winter Brook Series II*, by Nita Engle, the backlight shines through the trees, reflects on the snow, sparkles on the brook's surface, sneaks through branches and diffuses at the light source, eating away the branches and tree trunks. The shadows support the light source and describe the contours of the snow. With the addition of light on the open—as opposed to iced-over—stream surface, opportunities for sparkles abound.

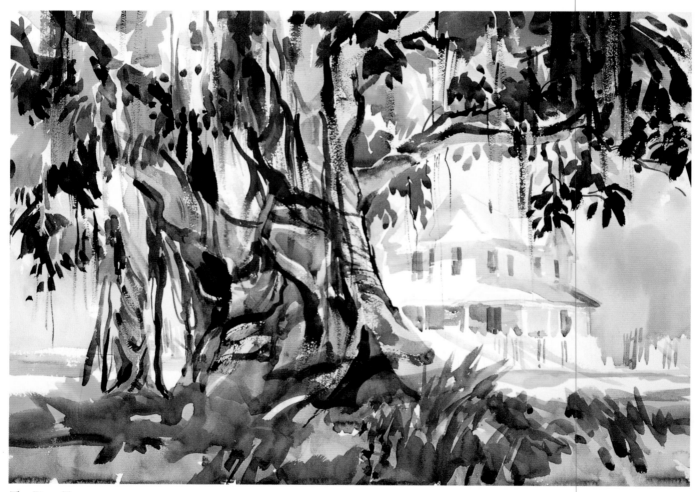

The Ficus Tree
22" × 30" (55.9cm × 76.2cm)
Judi Wagner

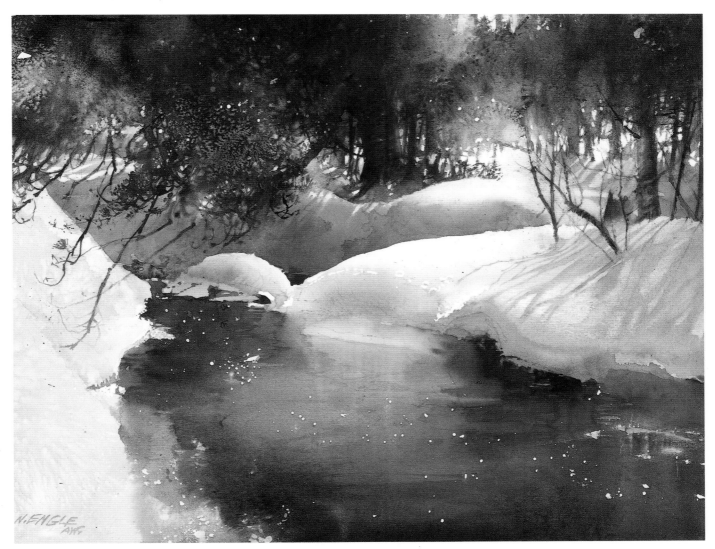

Winter Brook Series II
22" × 30" (55.9cm × 76.2cm)
Nita Engle

Try Painting Two Against One

2″ × 3″ (5.1cm × 7.6cm) Value Pattern
This thumbnail sketch is typical: The problem is that it fails to identify which of these three shapes is most important.

Instead of looking at a landscape and identifying the sky as the light shape, the trees as the dark shape and the fields as the middle-value shape, decide to *feature* one or the other in the painting. If you feature the sky, create the shape with light and middle values (two) against darker values (one). If you focus on the trees, design a dominant middle and dark shape against lighter values.

Specifying a dominant area defines your goal. Using a greater range of values for the important shapes allows for greater definition, variety and nuance. This goes hand in hand with the old advice: "When painting the focal point, look at the focal point. When painting everything else, look at the focal point."

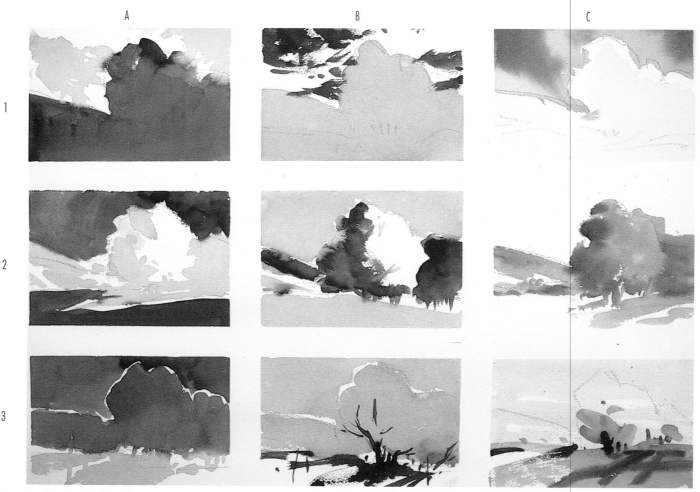

Two Against One Value Chart *Here are nine value variations from a single scene. By changing the relationship of the two values (reserved for the focal point) against one value (the "everything else" portion of the painting), we can create numerous patterns from one subject. The horizontal rows keep the same focus but change values. Row 1 emphasizes sky; row 2 trees; and row 3 foreground. The vertical columns illustrate changing focus. Column A is light and middle values against dark, with the focus changed from sky to trees to foreground. Column B is light and dark against middle values. Column C is middle and dark against light values.*

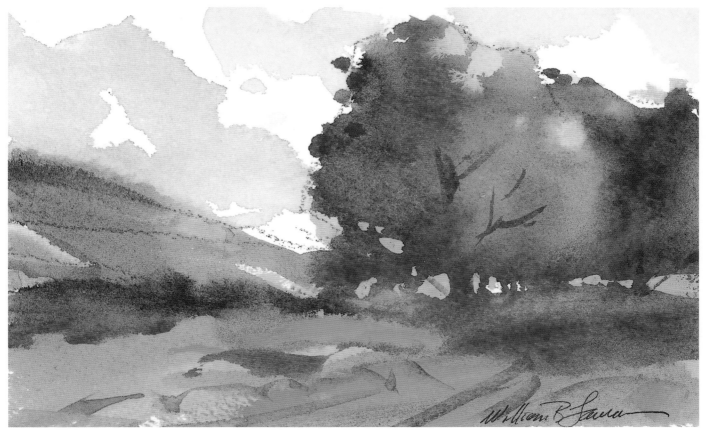

This little watercolor provided the shapes for the two against one value chart. It was done in a straightforward approach, which is certainly an option when painting. The problem is that, for some, it is the only option.

From the Studio
4¼" × 6½" (10.8cm × 16.5cm)
Skip Lawrence

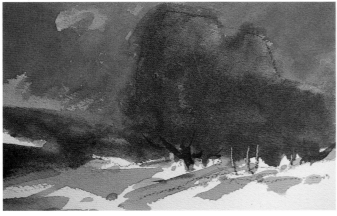

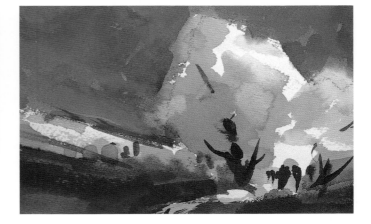

These two variations, of the same size, are color examples from the value chart.

Warm Next to Cool

Alternating the temperature of shapes from warm to cool is a simple and effective way of making the shapes of your painting read clearly. With this approach, as with any color-based approach, it is not necessary to rely on value contrast. Nor is it advisable to allow value contrast to override the subtle beauty of temperature changes. Alternating temperatures are not limited to juxtaposing shapes, but can also be used to enhance shapes by layering cool colors over warm and vice versa.

This painting was done for the warm light and the cool shadows. If you look closely, you will see that any surface that received light was painted in warm colors; those surfaces in shade were painted exclusively with cool colors.

High Noon
15½" × 22" (39.4cm × 55.9cm)
Skip Lawrence

Pure Colors Next to Neutrals

In general, all watercolor artists grow along the same route. First is the understanding of seeing and painting in values, followed by temperature and hue; awareness of changing intensity relationships comes last. The next time you go out to paint, look at the subject and, instead of identifying shapes by value or color, seek out the most intense color. Distinguish the range of intensities from purest color to absolute neutral, and then make a painting that emphasizes an intensity scale. You will be dazzled by the results.

Mountain landscapes are difficult because they demand aerial-perspective solutions. In this case, the problem was solved by reducing value and thinking only in intensity relationships.

Off Springmaid Mountain
20" × 26" (50.8cm × 66cm)
Skip Lawrence
Collection of Gerald McCue.

Expressing the Color of Light

Light comes in a full spectrum of hues. Just west of Mt. Airy, Maryland, are the Blue Ridge Mountains. The mountains of Albuquerque are called Sandia, which means watermelon, because of their bright red color. "Purple mountains' majesty," a line from *America the Beautiful*, refers to the color of distant mountains. Anyone who has seen these mountains knows that none of them are blue, purple or red. It reminds one of the first grader who was told by his teacher not to leave a space between the sky and the grass, because they actually do touch. The boy responded, "I've been there and they don't."

The effect of light and atmosphere creates the colors of blue, purple and red. The Blue Ridge Mountains are the result of looking through veils of blue atmosphere illuminated by clear white light. Mountains only appear purple when backlit by warm yellow atmosphere. The mountains of Albuquerque appear red only when an orange sunset reflects off the pink face of Sandia. What

Obviously, the colors Lawrence saw when painting in Crystal River, Florida, were not this orange. Just as obvious is that Florida is both warm and famous for oranges. Running sequential washes of Winsor Yellow, New Gamboge and Permanent Rose established a color dominance, a warm mood and an expression of essence. A few touches of blue-green exaggerate the orange and, by temperature contrast, complement the warm.

Florida Orange
20" × 26" (50.8cm × 66cm)
Skip Lawrence

we actually see is the color of light.

An awareness of and sensitivity to the color of light, be it natural or artificial, adds greatly to your expressive vocabulary. Don't allow your brain to dictate to your eyes what they are seeing. By identifying the ambient light, you have the tools to create various moods in your paintings. The white light of summer, pink sunsets, green moonlight scenes, yellow-green spring days, red-violet rains and yellow-orange fogs are all created with the color of light. Many excellent landscape paintings are done on days when the atmosphere turns a decided hue—and local color yields to that hue. English painter Trevor Chamberland does a lot of painting in inclement weather. Much of his decision to paint in fog and rain is dictated by the climate of England. The advantage to painting in fog, rain, sleet, snow and thunderstorms is the color of light—light that provides a dominant color to unify the areas of the landscape into a cohesive oneness. The next time it rains, instead of postponing your on-location painting, pack up your stuff and take advantage of the opportunity.

To this point we have been talking about cause and effect: Moods are dictated by Mother Nature. But you are not obligated to wait for a thunderstorm to create a mood in your painting. As the artist, you can create any mood you want at any time you want. If it suits your purpose to paint the world orange for any reason—just do it! Remember that local color is just one truth about a subject—the visual truth. Think about how you truly feel about the subject or the truth of how the subject physically feels. Include all your senses, understandings and emotions when deciding on the mood or dominances of the painting.

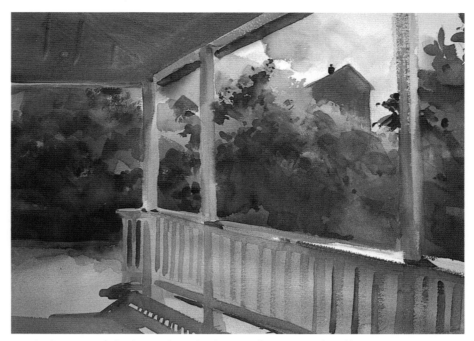

Local color, perceived color *and* actual color *are all terms used to describe the colors we see. Nature's colors are generally muted. Fire-engine red, white and black are rarely colors we see in nature. Consequently, representational painters tend to paint in tones. Even when bright hues are offered, they're not applied in pure form. This painting shows the neutral tones of nature with even the red color of the roses downplayed.*

The Elfant Cottage
20" × 26" (50.8cm × 66cm)
Skip Lawrence

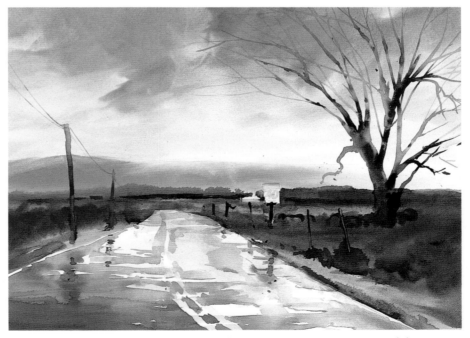

The sky is done wet-over-wet with Yellow Ochre, Permanent Red and Cobalt Blue. The triad of primary colors gives an overall effect of neutrals. These same pigments are used on the wet road. The land is painted in glazes that will be seen as dark and neutral.

Near Mountaindale
22" × 30" (55.9cm × 76.2cm)
Skip Lawrence

Painting the Actual Color

The ability to identify actual color is not as simple as it sounds. To correctly identify color, first cleanse your mind of any preconceived notions of colors you have been conditioned to see. Skies, for example, are rarely blue. Second, identify color in relation to surrounding colors. A red ball on a green floor is a very different color than the same ball on a yellow floor. Third, be specific about color's subtle changes of value and intensity. Last, remember that the three-dimensional world, from which we gather our color clues, is filled with reflection. Every color we see is reflecting onto every other color. It is this reflection of color that makes even opposite colors harmonious. The flat surface you paint on cannot reflect a color onto its neighbor. Therefore, it is your job to make the color changes necessary to achieve the same effect.

The truth is that local, or actual, color is of little value—other than as a beginning point. The best paintings are not those that match local color to *record* the truth, but those that exaggerate color to *express* a truth. Be sensitive to color: Look at the scene, the room or the figure and identify the ambient color, temperature and intensity. Then use that information expressively and compositionally. The color of the ambient light affects the color of everything it touches. If the sky is blue, there should be evidence of blue on every plane that the blue light falls on.

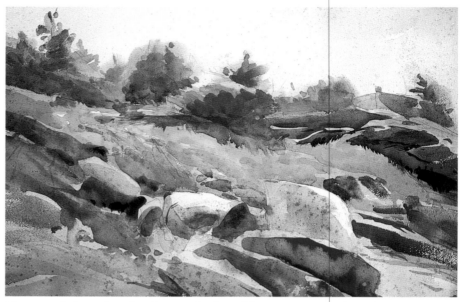

There was little need to alter the actual colors of this scene. The warm-neutral yellow-green of the middle ground was set off by the cool-neutral colors of the rocks, distant trees and sky.

Moors of Monhegan
15½" × 22" (39.4cm × 55.9cm)
Skip Lawrence

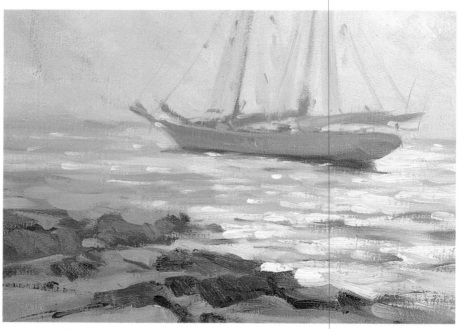

Don Stone, of Monhegan Island, Maine, has a rare ability to observe nature's subtleties. This painting is flooded with light, yet the color hasn't been lost. Notice the warm rose color that seems to be evident in the blue water, gray rocks and white schooner.

Schooner
Oil on canvas
10" × 14" (25.4cm × 35.6cm)
Don Stone

Painting Expressive Color

Our impressions of a place are the result of many realities, the visual reality being only one. How you feel about a place might be in direct conflict with its appearance. Artist Skip Lawrence has been to brightly colored places that he hated—the reptile trailer at the county fair, for instance—and understands that blue skies, blue-green water and green foliage (all from the cool side of the color wheel) are not very expressive of the warmth of a tropical island. On the other hand, he has been extremely excited by a foggy day in Maine, knowing that Payne's Gray won't convey his feelings of joy. Of course, one should not allow enthusiasm for a place to negate the very essence of the subject. At Lawrence's first critique at his first workshop with Edgar Whitney, Whitney exclaimed, "Bring this kid all the way to Maine, take him to a worm-ridden, dirty old boat yard, and he paints a damned Mardi Gras." The problem was that his painting was not a response to the boatyard, but rather an expression of enthusiasm for the situation.

Take time to look beyond the visual facts and find the colors that express your feelings. At times the local colors are appropriate for the subject, and at times they are totally inappropriate. You need only look at the work of great painters to realize that many of their color choices are expressive, not factual.

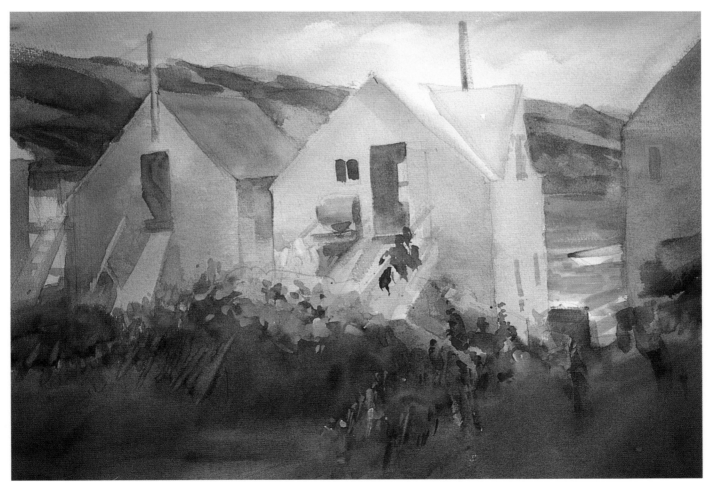

Lawrence painted this fish house to achieve the subtle quality of light. The houses, harbor and Manana Island were only objects that lived in the light and provided an opportunity to paint the light.

Alfred's Fish House
20" × 26" (50.8cm × 66cm)
Skip Lawrence

Making a Good Composition

This chapter provides a number of cautions that will help you design stronger paintings.

Twelve Errors to Avoid

1. Dividing a composition into equal parts horizontally or vertically can lead to a static composition. Avoid horizontal lines that slice a painting in half, as well as trees, posts, masts of ships or other elements that dissect your composition vertically into equal parts.

2. Dividing your design into too many similar shapes will produce an uninteresting painting. Likewise, be sure the spaces between objects aren't all the same width or height.

3. Don't include so many tension-creating shapes that the composition becomes busy or irritating, unless that is your intention.

4. When using converging lines, be careful you aren't "kidnapping" the viewer's eye and preventing it from moving through the painting.

5. Placing interesting shapes or elements at the edge of the composition steals attention from the center of interest.

6. Perfectly shaped triangles in the corners of your composition can draw the viewer's attention away from the center of interest. If triangles are unavoidable, soften the edges or stagger the forms.

1

2

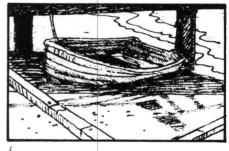

3

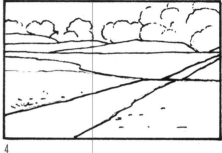

4

5

6

7. Avoid "visual traps"—lines, values or shapes that meet at the same point (such as a tree, a road and the horizon). If your composition includes an element with a strong perspective, such as a road, it's usually best not to show where the converging lines of perspective meet; otherwise, the viewer's eye is likely to follow the perspective path to a visual dead end at the vanishing point.

8. Be careful not to change technique in the middle of a painting. If you've begun a scene using mostly tonal changes (value against value), adding an outlined line drawing (such as the boat in this example) will almost certainly look "out of key" with the rest of the painting.

9. Be aware of static shapes. Here, for example, the dark, opened doorway creates a static shape that becomes a visual trap. It's better to modify it with a graded tone or a cool-to-warm transition.

10. Cast shadows can be effective as design shapes, but if they are too dark and sharp-edged, they can easily become "visual holes." If, for example, the shadow of a tree falls across vegetation and rocks, exercise a little artistic license and lighten it to allow the rocks and vegetation to be seen more clearly.

11. Watch for edges of planes or lines that lead to the corners of your composition.

12. When laying in your initial washes, block in the largest shapes first. Defining smaller shapes too early can fragment the image and make it difficult to create visual unity.

7

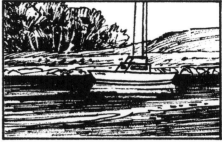

8

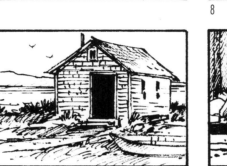

9

10

11

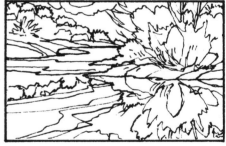

12

Positive and Negative Shapes in Nature

The moment you draw a shape, you also define the shapes that surround it; this, in a nutshell, is the idea of positive and negative shapes. The dominant shapes in a painting—a tree, a mountain or a fence, for example—are called the positive shapes. The "leftover" areas and any "holes" (such as where the sky shows between the branches of a tree or the rails of a fence) are the negative shapes.

When painting from nature, there's a temptation to paint things exactly as they appear. Unfortunately, nature is not always visually ideal. Many paintings of trees, for example, have a weak pattern of negative shapes in and around the tree forms. If the clumps of foliage are too symmetrical, they become static and uninteresting. The same holds true for the negative sky shapes. Both the positive tree foliage and the negative sky shapes need to be well designed.

This diagram of *October Sky* (at right) shows how negative shapes can support and complement positive shapes.

October Sky
25" × 39" (63.5cm × 99.1cm)
Robert Reynolds

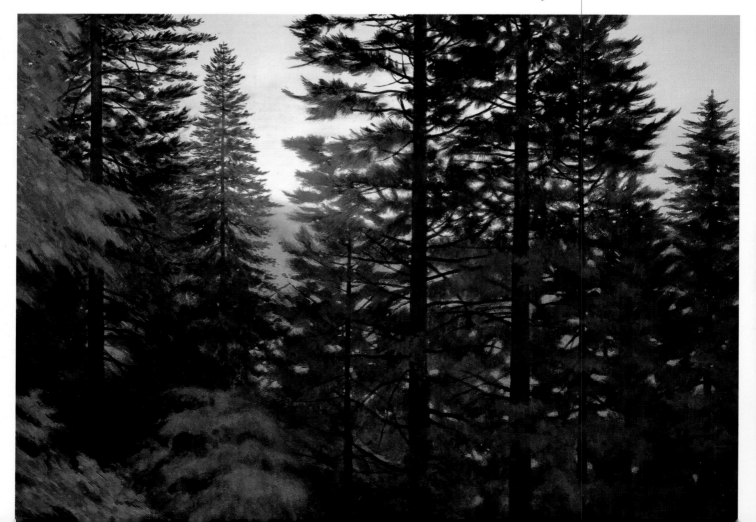

Positive and Negative Sketching

When you're drawing a preliminary sketch for a painting, outline a rectangle in your sketchbook in the same proportion and format as the painting. This forces you to consider both the positive *and* the negative shapes, and helps you avoid creating shapes that would appear awkward within the rectangular format of the finished painting.

We tend to think of negative shapes as voids or, if you will, "air." But solid objects that support the main subject can also be considered negative shapes. In the schematic pattern of positive and negative shapes for *Fir and Penstemon* (shown right), the sky is a negative shape, as are the flat, diagonal rocks that trail off toward the bottom right corner and also serve as supporting shapes.

This schematic shows the arrangement of the positive and negative shapes in the painting Fir and Penstemon, *shown below.*

Fir and Penstemon
25" × 39" (63.5cm × 99.1cm)
Robert Reynolds

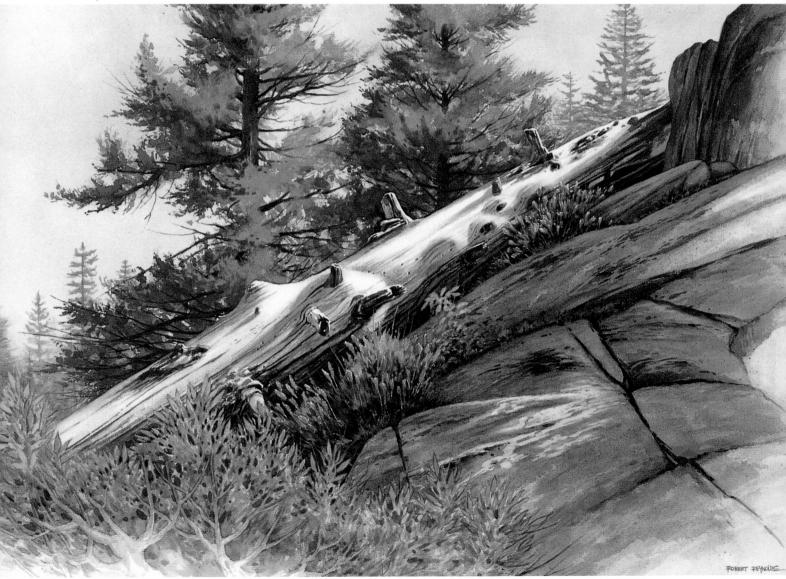

Creating Depth Using Perspective

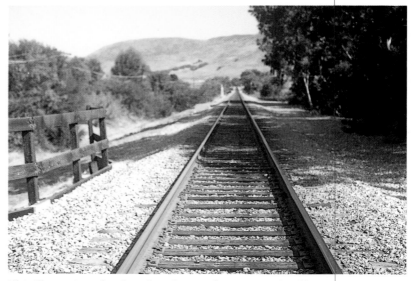

From a composition standpoint, the arrangement of shapes that are flat and two-dimensional is quite important, but landscape paintings also call for the three-dimensional illusion of space and volume called *space* or *depth*.

Artists have a variety of tools at their disposal, but linear perspective is one of the simplest and most effective ways of creating the illusion of three-dimensional volume or distance on a two-dimensional surface.

Linear perspective can be complicated if you're an architect, but for landscape artists, a basic understanding is usually all that's necessary to noticeably improve the believability of landscape drawings and paintings. Of course, the use of perspective isn't a substitute for creativity and artistic judgment; A perfectly drawn landscape isn't automatically a work of art. Keep that in mind if you're tempted to rely too much on mechanical aids such as opaque projectors, which appear to circumvent the need for drawing—but discourage creativity in the process.

Basically, *linear perspective* is the name for the illusion of distance created when parallel lines appear to converge at a point in the distance—as in this classic example of railroad tracks.

Key Perspective Terms and Concepts
Horizon Line or Eye Level

Here's a simple trick that will make it easier to establish your horizon line or eye level: With your arm outstretched in front of you, look straight ahead and hold a pencil horizontally, level with your eyes. Then close one eye and, without moving your head or eyes, visually determine whether key objects in your

This illustration of railroad tracks is a classic example of linear perspective, where parallel lines appear to converge at a point on the horizon line called the vanishing point.

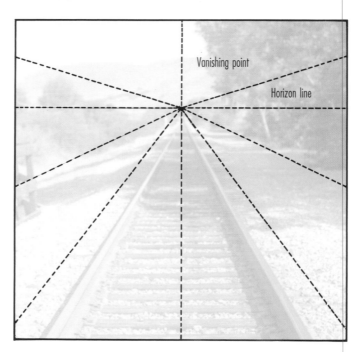

Basic Nature Painting Techniques in Watercolor

field of vision, such as trees, mountains or clouds, fall above, below or on the horizon line indicated by the pencil.

Vanishing Points

Creating the illusion of depth using perspective is based on the principle of *convergence*; i.e., that lines extended from the edges of objects (other than those whose sides are exactly parallel to the viewer) will eventually converge, like the railroad tracks, at a point somewhere along the horizon line. The point at which these lines meet on the horizon line is called a *vanishing point*—the point at which the lines effectively vanish from view.

Picture Plane

Imagine that someone has erected a wall about an arm's length in front of you. Also imagine that this wall has a window, level with your eyes, through which you are able to see a portion of the scene before you. This imaginary window is the picture plane.

If you could take a pencil and trace the outlines of each of the objects in the scene onto the glass in that window, you'd successfully transpose those three-dimensional objects onto a two-dimensional surface. If you then transferred that drawing from the glass into your sketchbook, you'd establish correct perspective and proportion for each of

the objects in the scene.

Although you can't draw lines on an imaginary window, the picture-plane concept does help define the limits of the scene and, at the same time, provides a framework for measuring the relative sizes and placement of objects within that framework. In other words, the picture plane—like the edges of your sketchbook or watercolor paper—defines the limits of the scene. In a similar manner, the imaginary top, bottom and sides of the picture plane provide convenient reference points you can use to determine the position and relative sizes of all the key elements in a scene.

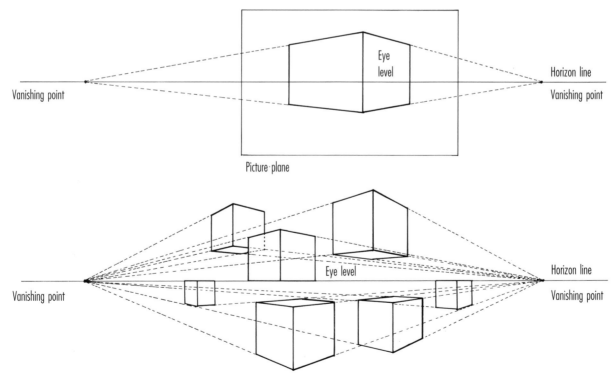

If an object is below the horizon line, lines extended from its edges converge, like the railroad tracks, upward toward a vanishing point on the horizon line; if the object is above the horizon line, lines extended from its edges will converge downward toward a vanishing point on the horizon line.

Other Ways to Create Depth

L inear perspective is not the only means artists have to create the illusion of three-dimensional space and distance on a two-dimensional surface.

Overlapping

The overlapping of forms is perhaps the simplest way to suggest depth in a painting; it can convey the illusion of depth across a shallow space, such as when rocks or trees overlap, or it can suggest deeper space, such as when several mountain ranges overlap in the distance.

In nature, the spatial relationships between closely spaced rocks or trees may not always be apparent; confusing spatial relationships can be resolved with a bit of artistic license by making one form overlap the other slightly. This will not only improve the readability of the image, but will also add variety and create a more interesting arrangement of shapes.

Natural vs. Geometric Forms

Unlike architects and engineers, landscape artists are seldom required to depict boxlike shapes such as buildings. But because these shapes are easily rendered using the rules of perspective, artists usually find it helpful to relate objects in nature to various geometric forms, such as cones, cylinders and cubes. A group of rocks, for example, can be viewed as a unit of related shapes that appear above, below or across the horizon line. Then, to create a believable sense of volume, the rocks can be "visually" enclosed in boxes to determine where the top, sides and bottom are located in relation to the horizon line.

Other objects, such as fallen trees, can be visualized as cylinders; cross contours can be used to suggest their volume, location and direction, and to relate the cylinder shape to the horizon line and the picture plane.

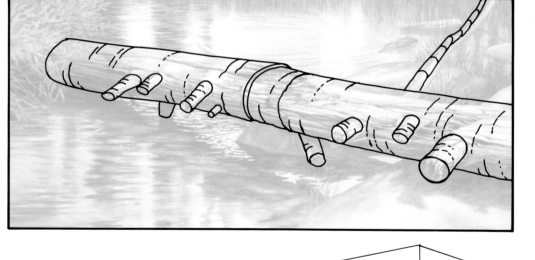

In this detail of Shimmering Water, the three-dimensional quality of the log is conveyed by three main elements. Light and shadows falling across the bark describe its form. Occasional "notches" or cross-sections of the bark's edges convey the elliptical shape of the log. Finally, broken limbs extending at various angles help convey the foreshortened form of the fallen tree.

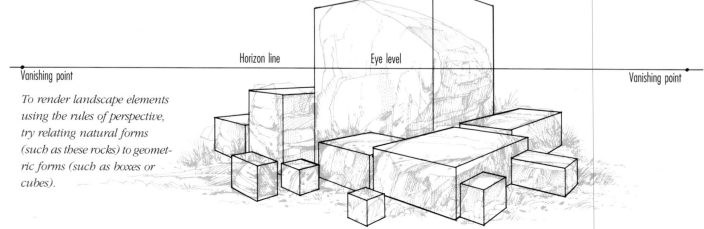

Horizon line Eye level

Vanishing point Vanishing point

To render landscape elements using the rules of perspective, try relating natural forms (such as these rocks) to geometric forms (such as boxes or cubes).

Overlapping forms and lost-and-found edges are used to convey depth in this painting. Also, the soft edges of the background trees are contrasted with the sharpness and detail of the foreground elements.

Autumn Golds
25" × 39" (63.5cm × 99.1cm)
Robert Reynolds, Collection of Carol Todd.

Shimmering Water
25" × 39"
(63.5cm × 99.1cm)
Robert Reynolds
Collection of
Kirkwood Ski
Resort, Kirkwood,
California.

Painting Nature Step by Step

Painting Big Shapes With Strong Values

DEMONSTRATION — Eric Wiegardt

Step One
Sky Values

This painting captures the clouds seen so often in the Northwest when a sou'wester kicks up its heels. To keep the value relationships realistic, keep some of the heavily clouded sky lighter than the ground plane. Also drop some of the sky color into the foreground and water to establish a unified color harmony.

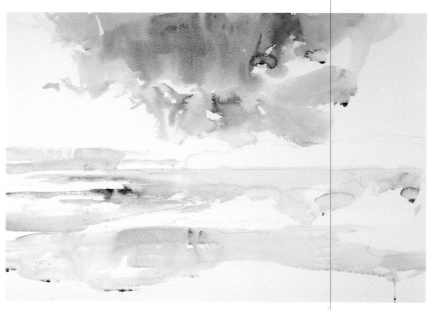

Step Two
Tree Masses

Establish the tree masses by making them a much darker value than the sky. Assigning them a dark value defines them as trees. A wet brush softens the detailed edge of the tree line where it meets the sky.

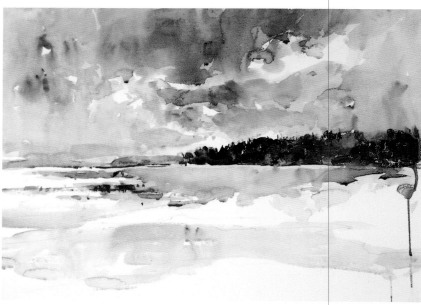

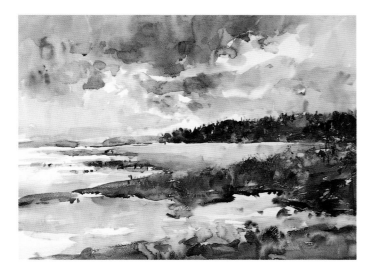

Step Three
Foreground and Background

Establish the foreground mass: The overall value relationship is important. Pick out a few grass blades for detail and indicate, or suggest, the rest, being careful not to distract the viewer's eye from the area of dominance. Make the background under the tree mass a lighter value for two reasons: (1) The strong value contrast against the trees helps draw the viewer's eye to an area of dominance; and (2) The change in value from foreground (dark) to background (light) helps establish a sense of depth.

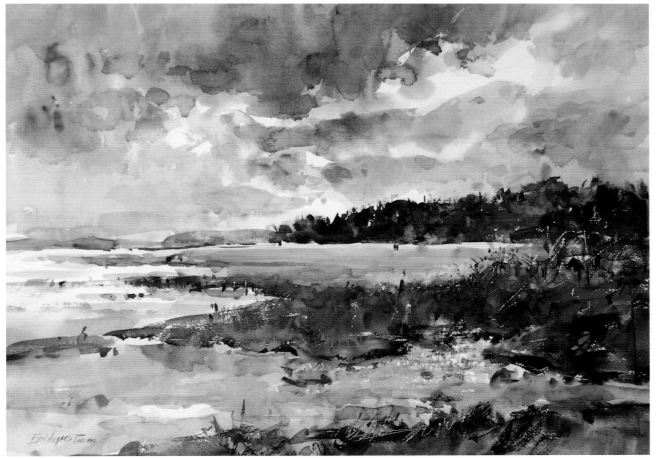

Sou'wester at Leadbetter
Eric Wiegardt

Step Four
Figures and Highlights

To finish the painting, suggest two small figures on the beach to provide a sense of scale and interest. Add a little more detail to the foreground, and then use a razor blade to scratch highlights into the water and grass. Make the grass mass under the figures warmer, drawing the viewer's eye toward the figures.

Combining Opaque and Transparent Watercolor

DEMONSTRATION — Douglas Osa

 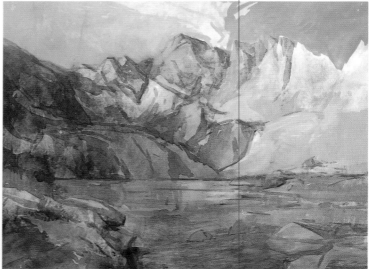

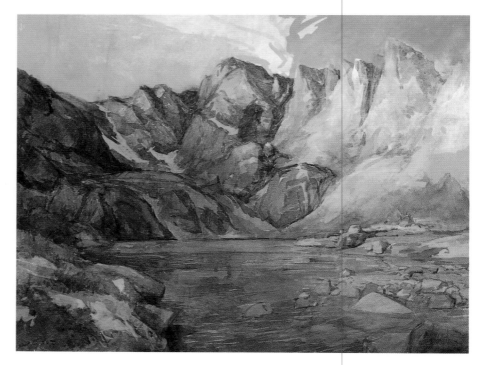

Step One

Osa began this painting with an old watercolor he had lying around the studio. He scrubbed out the image that he wasn't happy with, leaving just the basic shapes to use as the foundation of a new painting.

Step Two

To recapture the lights, Osa used opaque gouache, especially on the right side of the scene where the sun was hitting the mountains. For the shadowed left side, he used dark, transparent watercolor.

Step Three

By this point, the masses of color and values are all in place. Osa works back and forth with opaque and transparent color so that the total painting will be unified.

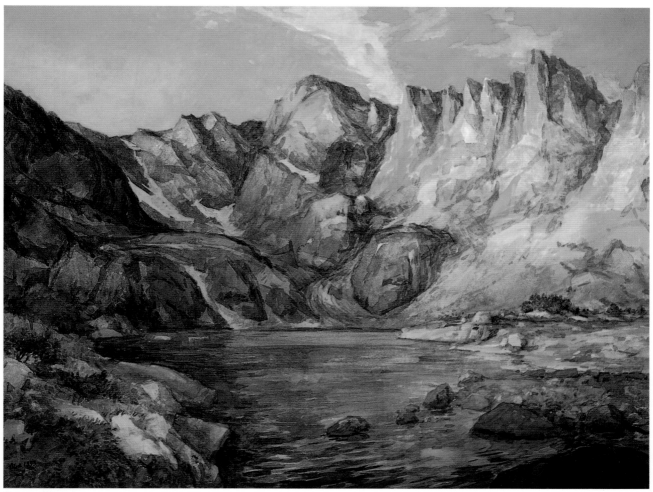

Step Four

The last step is adding detail and smoothing unwanted hard edges. Notice how he blended the passage from sky to cloud.

Sky Pond
18" × 24" (45.7cm × 61cm)
Douglas Osa
Courtesy of Hensley Gallery
Southwest, Taos, NM.

Save Your Whites Wisely

DEMONSTRATION — Dale Laitinen

Laitinen's goal as a painter is to eliminate white where it is not needed, as a sculptor does when cutting away unnecessary stone.

When "cutting away" the light on the paper, he remains alert to the possibilities as they present themselves. He thinks about each layer of color as a transparent lamination. With each lamination he blocks out more and more white, until only the essential lights are left, making these lights more luminous. *Lake Near the Crest* has a wide range of translucent passages, moving from the almost-white snow patterns to dark darks. In painting, everything is relative: What you put next to an element is what counts.

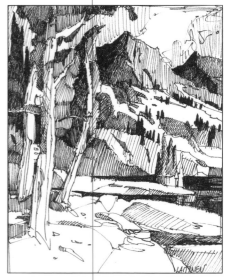

A preliminary value sketch helps visualize whites and lights. The snowfields create an interesting design against the dark mountain face. Mass in the dark lake as contrast to the light in the shoreline rocks. The lights in the trees, along with lights in the top and bottom of the format, unify the composition.

Step One

After the underpainting of Yellow Ochre, French Ultramarine Blue, Winsor Green and Burnt Sienna is completely dry, paint in the dark, cool sky so the clouds become warm and luminous, with the first washes shining through. The foreground shapes are defined with French Ultramarine Blue and Burnt Sienna; carefully avoid the tree trunks so they will not be affected by underlying color. The warm shoreline area represents underwater rocks to be glazed over later.

Step Two

After the underlying washes are dry, brush in middle values on the mountain range with a gray-purple mixture of French Ultramarine Blue and Alizarin Crimson. While this wash is still wet, add Cadmium Red and Yellow Ochre for warmth, and Cerulean Blue for richness in cooler areas to create luminosity. Be careful to paint around the lights—this produces a striking dark-light pattern with the almost-white snow.

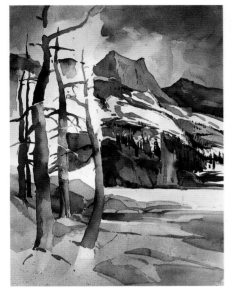

Step Three

At this stage, eliminate some lights so the remaining light will appear stronger. Paint a purple-gray mixture in the mountain shadows, and add Cerulean Blue for atmosphere and opacity. The heavier shadow passages and almost-black distant tree line make the lighter rock face and snow pattern even more luminous. Add the foreground tree trunks with both warm and cool colors to create the warm light on them.

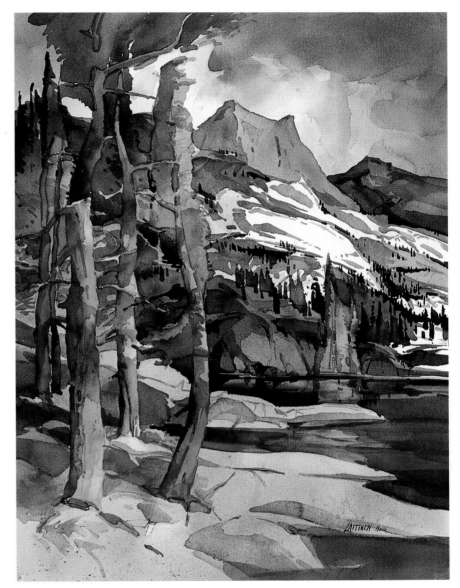

Step Five

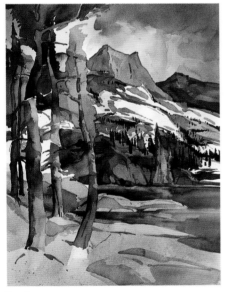

Step Four

Step Four

Using Cadmium Yellow, Burnt Sienna, French Ultramarine Blue and Winsor Green, mingle the colors over the warm lake rocks. These cool darks establish a strong edge to the foreground shoreline. Block in the foliage by filling in the blank white space around the trees. In the trunks, add shadows and detail for solidity and to enhance the glow of warm light on their surfaces. Some whites are saved for further background development.

Step Five

Fill in the white areas behind the trees, integrating the negative and positive shapes with the background and tying it to the rest of the painting. Finally, add detail such as bark texture and foliage.

▲ *Laitinen uses Arches rough in various weights and sizes.*
Lake Near the Crest
30″ × 22″ (76.2cm × 55.9cm)
Dale Laitinen

Find a Fresh Way to Paint a Familiar Landscape

DEMONSTRATION — Sharon Hults

Step One

After masking out the areas of the mountain and the foreground that will remain white, begin with a wash over the most distant part of the landscape.

Reference Photos *Hults, who frequently paints the mountains near her Colorado home, is constantly looking for ways to make the landscape look different. Here she finds an interesting tree shape to add to the mountain background.*

Step Two

Add numerous layers of washes, salting and spraying each to create the organic texture that characterizes mountain scenes.

Step Three

When the background is in place, remove the mask and complete the foreground. The finished painting is a fresh, luminous depiction of a mountain scene.

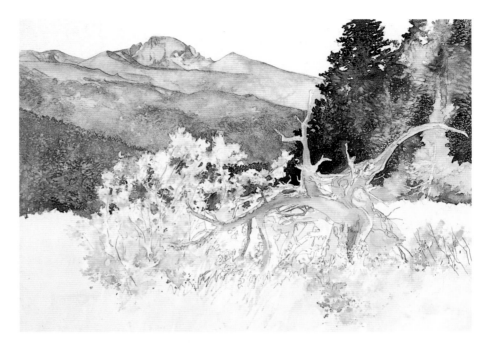

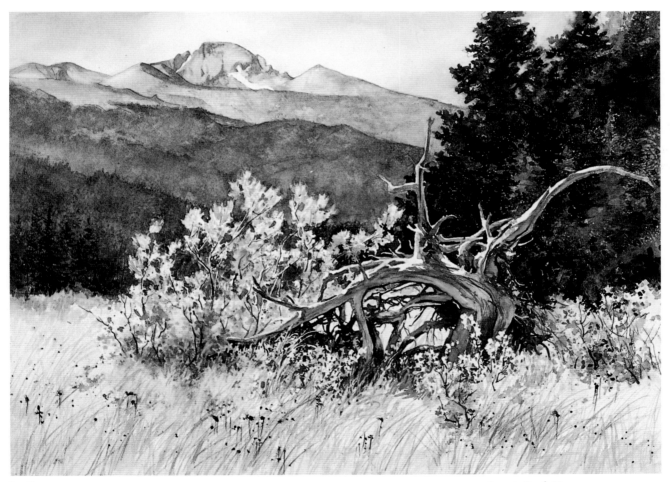

Step Three

Long's Peak II
22" × 30" (55.9cm × 76.2cm)
Sharon Hults

Getting Ready to Paint Outdoors

DEMONSTRATION — Tom Hill

The next three demonstrations were painted "on location," so here are some pointers for preparing to paint outdoors yourself. Many artists highly recommend that you add on-location painting to your routine. Your work will have more conviction and speak with authenticity, and you'll grow more rapidly into that better artist we all aspire to become! Something about that subject attracted you in the first place, so why not stay right there with that inspiration, where everything you need to know is right in front of you?

Your outdoor "studio" can run the gamut from minimal to elaborate, but it must be *mobile*—you have to be able to take it with you!

What equipment does one need to be able to go out and paint successfully at the site? As with so many other choices in life, it all depends.

At the very least, you could have a small watercolor set (like you had back in grade school), a little watercolor paper tablet, a brush and a small bottle of water. It's possible it could all fit into your jacket pocket or purse! It's also possible that traveling this lightly, you might have to sit on the ground and hold your painting in your lap. A good result is still obtainable, even with this small amount of painting equipment.

At the other end of the scale, you might have a large truck, van or trailer in which you could carry nearly as many painting amenities as you'd have in a home studio, and you could paint while inside this vehicle, away from bugs, weather, onlookers and so on. Most of us will want a mobile studio somewhere between these two extremes.

In general, your on-location setups will depend on your way of working, where your painting spot is located, and how much time and how many resources you have available.

Watercolor Paint

For outdoor painting, your choice of hues is related to the solar spectrum—the colors you see in a rainbow: red, orange, yellow, green, blue and violet. As artists' colors don't quite match the solar ones, get as close as you can, with a cool and a warm version of each.

- Reds: Scarlet Lake (warm), Alizarin Crimson, Permanent Rose (cool)
- Oranges: Mix from yellows and reds, also Burnt Sienna (grayed red-orange)
- Yellows: Lemon or Hansa (cool), New Gamboge (warm), Raw Sienna (grayed middle)
- Greens: Mix from yellows and blues, also Winsor or Phthalo (cool)
- Blues: Ultramarine (warm), Cobalt (close to a true blue), Winsor or Phthalo, Manganese or Cerulean (all cool)
- Violets: Mix from reds and blues

Most of your painting can be done with only five or six of the above hues.

Here's artist Barbara Luebke Hill painting on location. What a great, direct way to get inspiration and information all at once! To those of you who hesitate to paint outdoors: This may not be quite as comfortable as indoors, but it's pretty nice! The semitransparent umbrella cloth is white, so it stops the glare of direct sunshine but lets a nice, soft light through, and doesn't add any unwanted color to the watercolor paper surface.

Brushes

It's preferable to do most of the work with only two or three brushes. You might have 1½-inch (38mm), 1-inch (25mm) and ⅝-inch (16mm) oxhair or synthetic hair flat brushes, plus a couple of sable hair round watercolor brushes, maybe a no. 10 or a no. 8 and a no. 6. Sables are more expensive than oxhair or synthetic, but perform beautifully if properly cleaned and cared for. You might also want a no. 6 rigger or script brush for linear strokes. A ½-inch (12mm) oil painting bristle brush (called a *bright*) can come in handy for scrubbing out or lightening previously painted areas.

Paper

Some good papers to carry with you are Lanaquarelle, Fabriano and Winsor & Newton. A 140-lb. (300g/m²) cold-press (medium-texture) paper is adequate, but also try painting on the other common surface textures: hot-press (smoother texture) and rough.

Most often, with 140-lb. (300g/m²) paper, you'll want to stretch the sheet prior to going out in the field. Just soak the paper in clean water long enough for it to expand slightly. While it's still damp, staple or gum-tape the sheet around the edges to a lightweight watercolor board. When it's dry, it becomes taut and easier to paint on, because it resists buckling and wrinkling, and you have a ready-made painting board. A man-made board such as foamcore can also be used for this purpose.

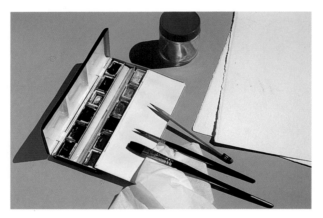

These two photos show how very small watercolor essentials can be! The ordinary pencil gives an idea of scale. Several manufacturers make these little-pan watercolor sets. In a situation where all your equipment must be kept small, painting "out of your pocket" might be the answer.

Here you can see a slightly larger paint box, allowing for larger brushes and paper and the more versatile moist tube colors—but you'll have to find a place to sit and something to prop your watercolor paper against!

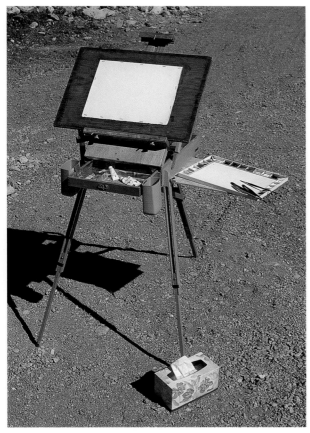

"French" easels are made for oil painters who hold their palettes. This one was modified with cleats underneath so a plywood tray could be slid in to hold the watercolor palette level.

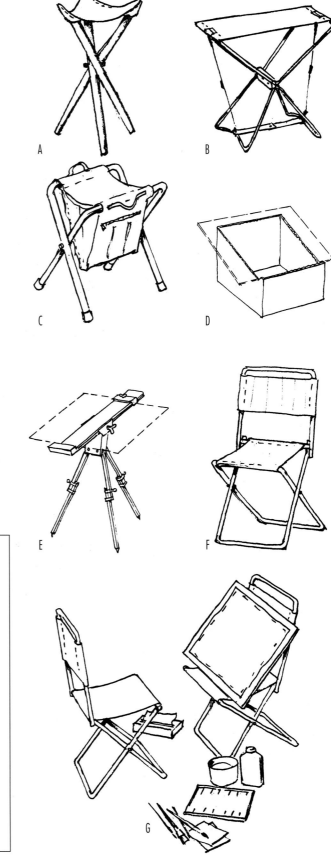

PORTABLE SEATS AND EASELS

Please be seated—or would you prefer to stand? Do both, depending on the situation. Here are a few suggestions—all are lightweight and portable.

- Three-legged stool that folds and has a saddle seat.
- Web seat that folds to a very small size.
- Reliable camp stool—this one has a canvas pouch under its seat.
- A sturdy cardboard carton, with the top cut at an angle and notched, holds watercolor board and carries gear too! You must either sit on the ground or put the box on a table.
- A folding, adjustable wooden easel; there's an aluminum version, too.
- Lightweight, folding camp chair
- Two folding chairs and your painting gear—an easy way to get started

Other Items

Most artists like to use two water containers when painting—one to clean brushes, and the other for dirty water. Absorbent paint rags or facial tissues are useful. A cellulose kitchen sponge and a small natural "cosmetic" sponge are useful, too. A pocketknife or craft knife is handy for scraping. Use a smooth-surface paper and softer lead drawing pencils when making drawings, composition plans and sketches. Pink Pearl erasers and kneaded erasers both remove graphite from the watercolor paper after the painting is finished.

How to Carry It All

How you transport your painting gear and materials to the site where you paint depends a lot on how you work, what size paintings you make, how far you must go, and whether you walk or drive. If you prefer to paint small paintings, then you might be able to get everything you need into a little backpack, an attaché case, a camera equipment bag or even a large purse. If you work larger, your carrying arrangement will have to be larger, too.

On this and the following pages are shown several solutions. Arrange all your painting things in a pile or group. This will give you an idea of what size case or bag you'll need. A visit to a well-stocked luggage shop might surprise you—the choices and sizes of bags and cases seem endless and you may find exactly what will fit your requirements.

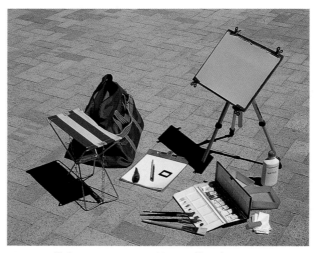

Here is all the painting gear Tom Hill took on a trip to Europe, where he had to travel lightly. Painting quarter-sheet watercolors, Hill was able to fit all you see here easily into the nylon bag, which measures 13″ × 18″ × 7″ (33cm× 45.7cm× 17.8cm) and carry it all with one hand!

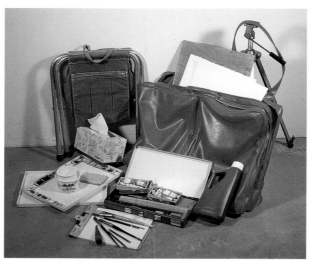

Tom Hill drew a dimensioned sketch of this red art bag, and then had the bag made at an awning shop. With a double-zippered top opening, zippered side pockets, a handle and a shoulder strap, it holds everything you see pictured here— and more. It's about 21 inches (53.3cm) high, 28 inches (71.1cm) wide and 4 inches (10.2cm) deep, and can travel with the rest of the luggage on an airplane. It was made about twenty years ago and is still going strong!

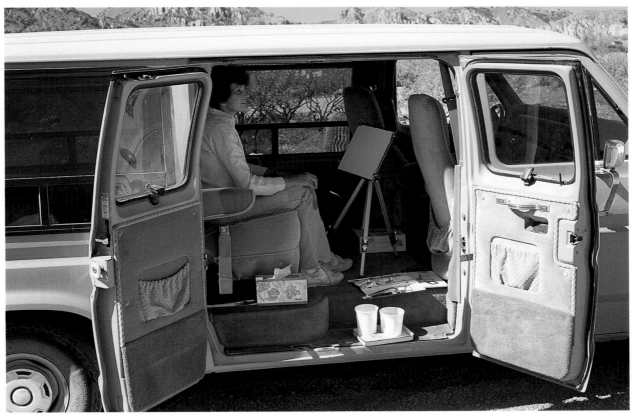

Some artists paint from the front seat of a compact car when the weather turns uncomfortable. It's tight, but they do it! The photo shows you how downright "comfy" a plein air painter can be, painting from the seat of a large van. There are also artists who've converted the whole back end of their RVs into studios! Painting from life can run the gamut, from a lap-held, pocket-size paintbox to a spacious studio on wheels!

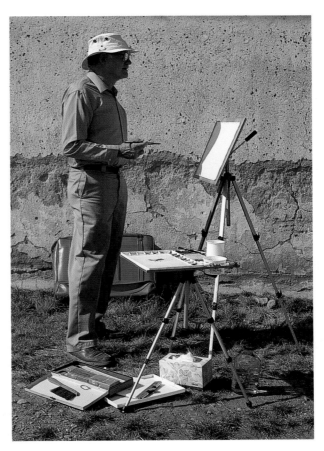

The larger photographer's tripod holds the watercolor board (screwed on from the back), while the small tripod supports an aluminum pan, making a nice level spot for palette, water and brushes. Everything you see here fits in the red bag behind the artist. (**Note:** You wouldn't really paint with the sunshine full on your paper! In this case, and in some other instances in this book, it's just for the clarity of the photograph.)

Capture Natural Color

DEMONSTRATION — Douglas Osa

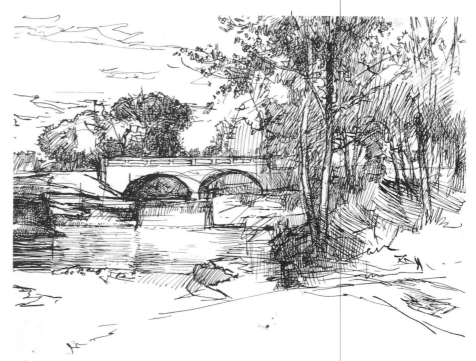

Value Study *In this sketch, Osa works out values and proportions. With these two studies completed, he is ready to begin the painting.*

Douglas Osa's approach to color is simple—use whatever it takes to capture the subject in front of you. Since his chosen subjects are natural landscapes, his palette consists of basic natural colors. He worries that the more brilliant, intense colors will actually detract from his subject.

Osa has painted with oils as well as watercolors, and he uses some of the same techniques for both. For instance, he likes to paint on a toned surface, so he begins by tinting his paper with a very light wash. He might leave some areas of white, or he might cover the entire surface with very soft tone. Sometimes he will paint on a piece of paper that contains a failed painting. He scrubs off the previous painting until all that is left is a light tone.

Divide the Composition Into a Few Simple Shapes

From there he divides the painting into large, simple color shapes keyed to what is actually in the scene before him. He indicates the areas of dark and light color and of warm and cool color. He uses a very diluted paint at this point so that he gets a neutral, washed-down version of the finished piece.

This lighter version of the color allows him to see how the composition will fit together, but still gives him room for refining and enriching color as he goes along. Dividing the total composition into just a few large shapes of color also helps him develop color harmony.

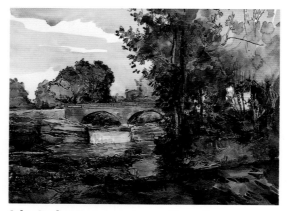

Color Study *"Early morning and late afternoon lighting conditions," explains Osa, "are especially beautiful because of the longer shadows and richer color caused by the low angle of the sun. These times of day also require quick, accurate decisions and decisive work to get down all the necessary information, in a color study such as this, before the light has changed."*

Catching the Subtleties of Nature

Osa paints on location as much as possible. He says there is no way a piece of film can capture the subtleties of colors outdoors. The film will skew the colors warmer or cooler. Light areas wash out and dark areas block up. If weather conditions are impossible for watercolor, he paints his color studies in oil and then paints the larger, more finished piece in the studio in either watercolor or oil. He feels there is no difference in importance between his watercolors and oils.

"The actual painting process is very traditional," he says. "I generally start the picture wet-into-wet, strengthening color and blotting until the composition is fully established.

"Where there is complexity of shapes and/or values, the painting is preceded by a light, careful drawing. I actually do most of my drawing on top of the initial washes of color. The reason for this is that in the past I was tightening up details before I was completely satisfied with the color development. What resulted was a stiff, tentative expression devoid of the subtleties that abound in nature. By eliminating the initial drawing, I can concentrate on color harmonies and tonal transitions.

"Once dry, this color can be manipulated through lifting, dry-brush and additional washes. I make use of gouache and body color (transparent watercolor with a little bit of Chinese White added to it) in some of my paintings, but never to simply paint out mistakes. Those I generally scrub out with a bristle brush and clean water. I've found the translucent quality the opaque color imparts to the transparent washes to be especially nice, particularly in the neutral halftones."

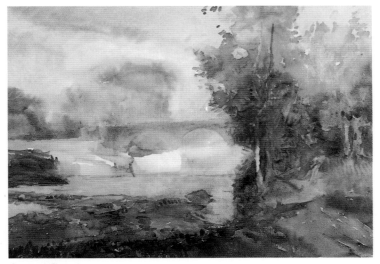

Step One

Osa begins by wetting his paper. When it is no longer glistening, he lays in large, flat washes of local color. As the paper dries, the strokes begin to hold their form.

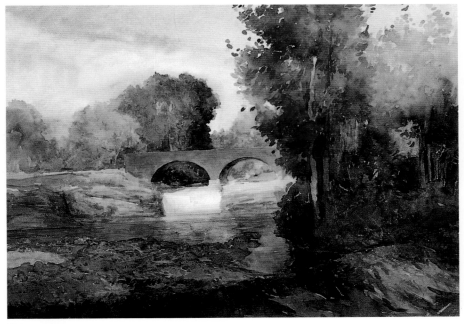

Step Two

He continues to strengthen the local color and deepen the value contrast between foreground shade and the fully lit waterfall and bridge.

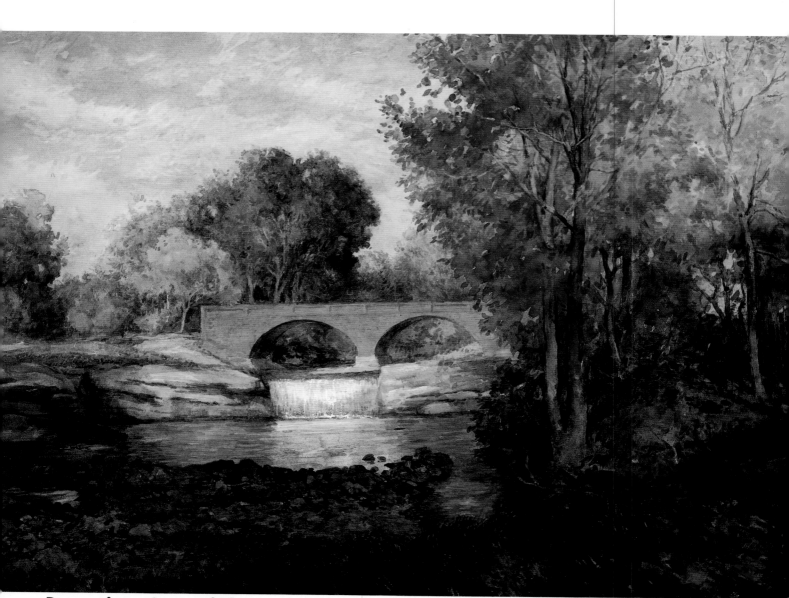

Preserving a Sense of Place

Osa avoids the tricks of the trade, such as salt and spattering, for the same reason he avoids high-intensity colors: He doesn't want anything to interfere with his capturing the "sense of place" unique to each location where he paints. He believes that technique should never get in the way of the image.

He says, "My painting techniques are as simple as you can make them, just brushes and paint and paper. I may draw lines in with a knife while the paint is still wet, but that's about as complicated as I get. I really don't think there's any way to get around good strong drawing and brush handling, and a good eye for color."

Step Three

He continues to add color and texture until the painting projects the atmosphere of the original scene. He picks out final bright highlights by scratching with a knife point.

Tryst Falls
21" × 29" (53.3cm × 73.7cm)
Douglas Osa

Painting an Oasis in the Desert
DEMONSTRATION — Tom Hill

Southern Arizona, where I live, is part of a desert that covers a large part of Arizona and extends south into Mexico. It's not as dry as many deserts, but water is still precious, so a natural and permanent body of water is rare and possesses a jewel-like quality. Not far from my house is such a phenomenon—an oasis in the desert. Fed by underground streams from nearby mountains, the water wells up to the surface, forming a small lake.

Over the years, grass, reeds, cottonwood and sycamore trees have somehow arrived at this oasis, taken root and prospered. In addition, desert palms have grown in profusion, their fan-like fronds waving in the passing breeze against a bright blue sky, while the many

shapes created are reflected in the calm waters below. Surrounding the oasis is the desert, surviving as it always has and lit by brilliant sunshine. The setting is at once arresting and visually and emotionally exciting, and begs for an interpretation in watercolor!

My Painting Goal

I wanted to capture, in paint, the wonderful feeling of contrast between the warm, dry desert and the cooler lushness of the foliage growing beside and sustained by the oasis.

Palm trees are amazingly constructed. I made several drawings of their structure so that I felt more comfortable trying to interpret them in watercolor.

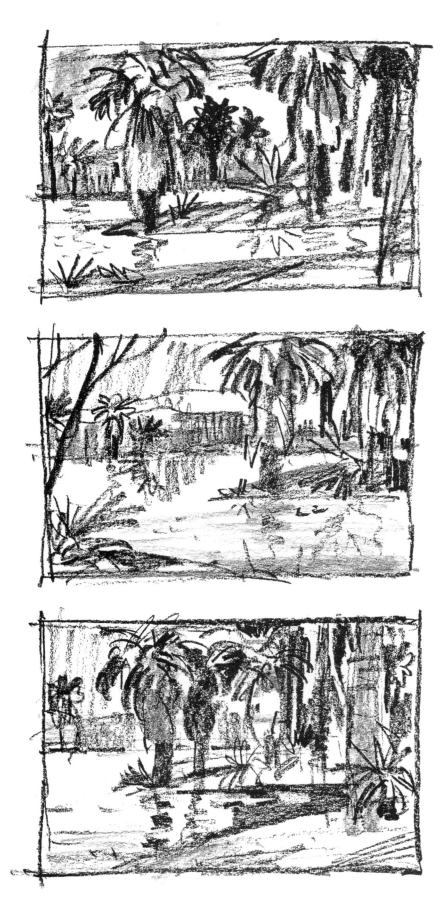

To arrive at a better design for my painting, I first made little 3" × 4" (7.6cm × 10.2cm) pencil roughs, or thumbnail sketches, trying out different arrangements of the shapes I saw before me. I settled for the one at the bottom, and transferred the design to my watercolor paper.

At the top of the facing page is a photo of my subject. Below it is my pencil drawing on watercolor paper, ready for paint. Although at first glance a scene like this seems almost perfect, it still needs some editing and rearranging. I have pointed out some possible faults in the actual scene, and what I thought would correct or improve them in the drawing.

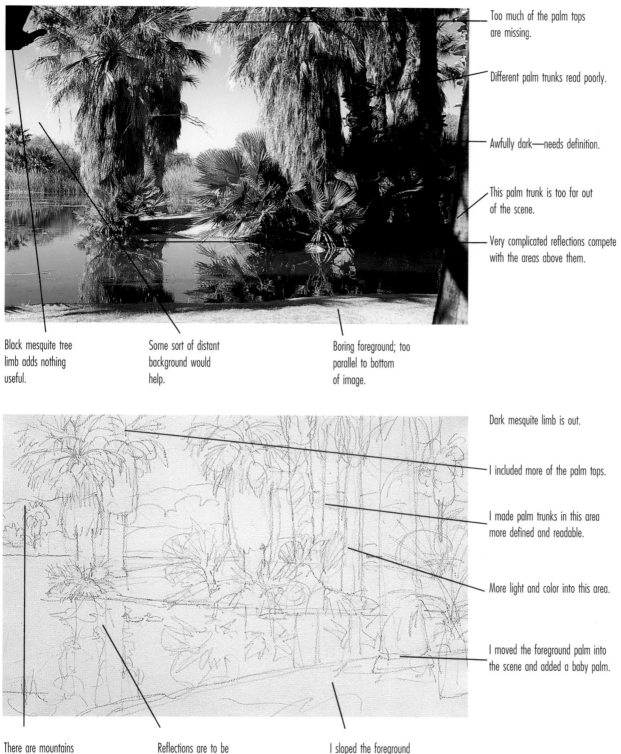

Too much of the palm tops are missing.

Different palm trunks read poorly.

Awfully dark—needs definition.

This palm trunk is too far out of the scene.

Very complicated reflections compete with the areas above them.

Black mesquite tree limb adds nothing useful.

Some sort of distant background would help.

Boring foreground; too parallel to bottom of image.

Dark mesquite limb is out.

I included more of the palm tops.

I made palm trunks in this area more defined and readable.

More light and color into this area.

I moved the foreground palm into the scene and added a baby palm.

There are mountains to the right of the scene. I decided to move them into my painting's background.

Reflections are to be made simpler, but still be reflections.

I sloped the foreground and planned to add cast tree shadows across it.

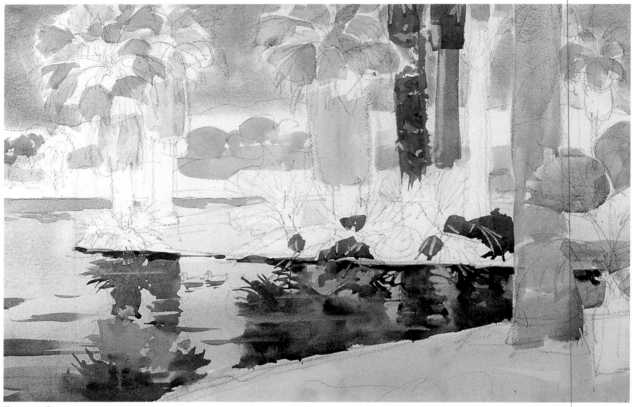

Step One

▲ Wet the lake area with clean water, and then paint sky reflections with Cobalt and Manganese Blue, using a 1½-inch (38mm) flat brush. While the area is still damp, drop in reflection shapes with 1-inch (25mm) flat and no. 10 round brushes, using mixes of Phthalo Green, Burnt Sienna, New Gamboge and Ultramarine Blue. Paint the sky area with the same blues as the water, and block in the shapes of palm fronds and trunks.

▶ **DETAIL** Here you can see how the reflections were dropped into the damp wash—simple shapes, some still wet and others already drying to crisp edges, echoing what was to be painted above them.

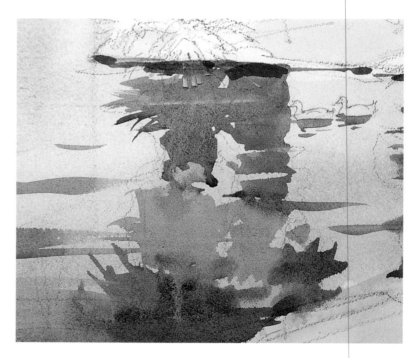

Basic Nature Painting Techniques in Watercolor

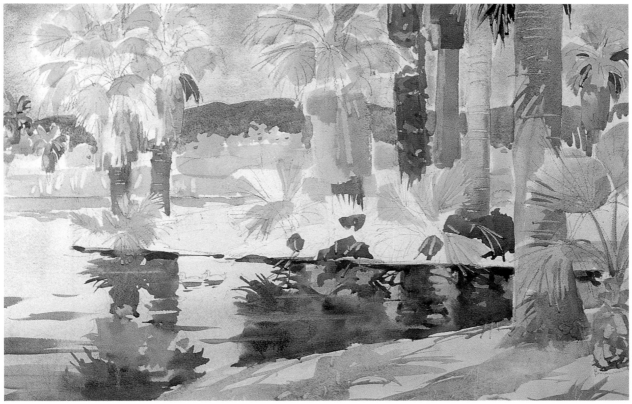

Step Two

Lighten the pencil lines with a kneaded eraser and then redraw some of the details more accurately. Next, paint the distant mountains, using a mix of Manganese Blue and Permanent Rose, still employing your 1-inch (25mm) flat brush. After this, paint cast shadows on the foreground and block in the baby palm in the right-hand corner and the shadows on the large, light-colored palm trunk in back of it.

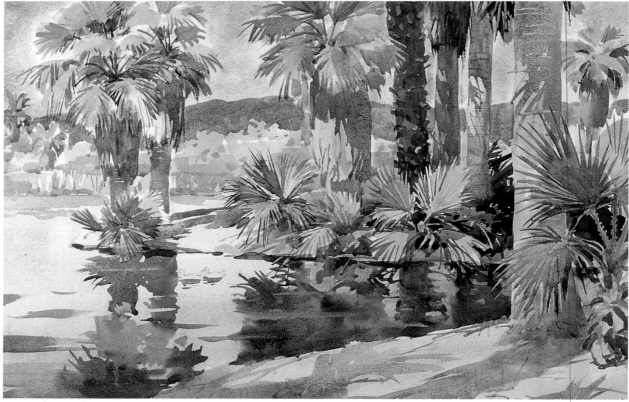

Step Three

▲ After the paper is dry, erase most of the pencil lines and then work on developing the palm shapes more completely, but still in an interpretative fashion, stressing shape and gesture more than detail. The dried "skirts" on the palms are painted more completely by painting their shadows using both warm and cool colors, depending on what colors of light are being reflected into them.

▶ **DETAIL** Cut around the previously painted palm frond shapes with darker colors to help define their shapes. Notice how warm, dark colors bring out and accentuate the cooler, lighter yellows and greens of the foliage.

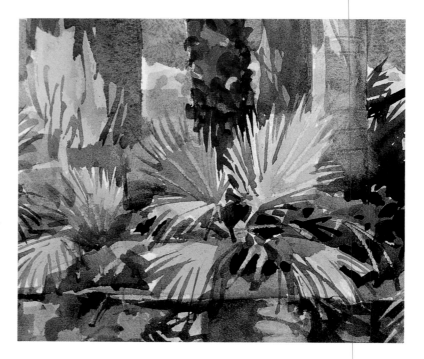

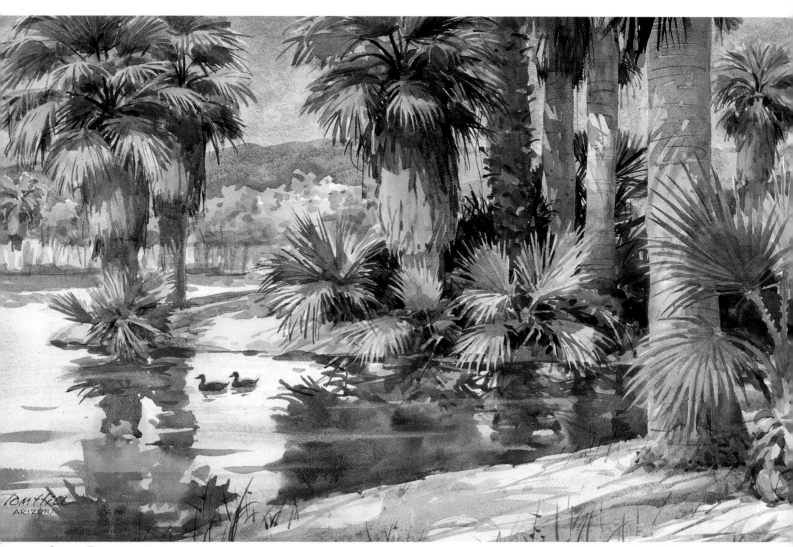

Step Four

When Tom Hill started to paint this scene, it was about ten in the morning. By the time he was finished with Step 3, the sun was nearing its zenith as it approached noon. So, taking the nearly finished watercolor back to his studio, Hill added darks under, in back of and around the palm fronds and trunks to organize and pull areas together, as well as to help shapes read better.

Paint the sky a little darker with a quickly applied wash of blue. Darken and clarify the shapes of the shadows in the foreground, and add more foliage between the middle-ground palm trunks.

To sharpen the detail in the frond points (especially where they hang out over the water), cut masking tape stencils in place with a sharp blade, and then lift out the dark color underneath with an old toothbrush. When dry, peel off the tape and add the yellows and greens to the now sharply defined frond tips.

The two little wild ducks that had been hanging around earlier were now rendered almost as silhouettes, adding a little more to the feeling Hill was after.

Oasis in the Desert
14" × 21" (35.6cm × 53.3cm)
Tom Hill

When trying to organize and compose a busy and complex subject like this, it's helpful to visualize the subject as a group of simplified shapes: The sky and peaks as one shape; the distant forested hills as other shapes; the lake as a shape; and the foreground as another. This approach is illustrated here, leaving out the detail. It's almost like cutting these shapes from colored paper.

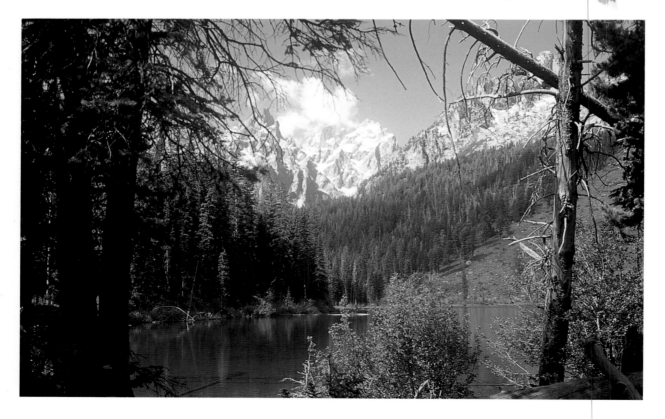

Basic Nature Painting Techniques in Watercolor

Painting the Grand Tetons

DEMONSTRATION — Tom Hill

The Grand Teton Mountains in western Wyoming rise thousands of feet above the valley floor like an enormous, ragged stone wall. Almost overwhelming in their grandeur, they are indeed the picture-perfect subject—a subject many artists have reveled in trying to capture. These formidable peaks, with conifer forests, meadows, streams and a string of jewel-like lakes at their base, offer timeless and inspiring picture possibilities!

My first attempts at painting this subject matter were done as demonstrations for an on-location watercolor class. As I struggled to successfully paint the complicated subject matter, I realized how much I didn't know about the subject—*and* how much I was learning with every attempt. The old wisdom about having to really know and understand one's subject to be able to authoritatively interpret it in paint came back to me with a rush!

After the class, I returned another time to paint what you'll see here. It's probably more knowledgeably painted than my first attempts, but I know there's still a wealth of things to be learned about painting these incredible mountains!

My Painting Goal

I hoped to interpret in watercolor the feeling of pristine and crystal-clear cleanliness that the setting offers—a setting that is a real challenge to paint successfully, avoiding a "pretty postcard" result.

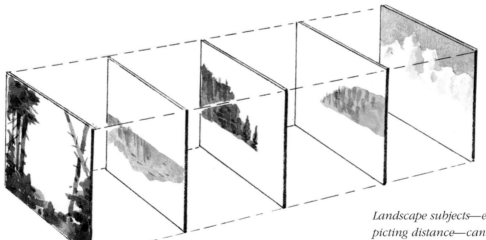

Landscape subjects—especially those depicting distance—can often be thought of as having planes in their makeup: a foreground plane; a middleground plane; and a background, or distant, plane. Other intermediate planes can be introduced, as in the diagram at left, if it will help in organizing and composing the picture.

I made this drawing of nearby fallen trees, and decided to incorporate them into the composition. The drawing helped a lot in my understanding of just how the trees lay and their size, color and texture.

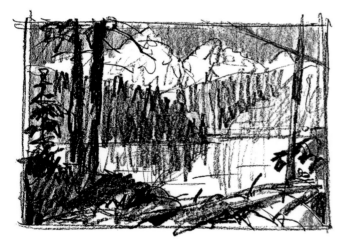

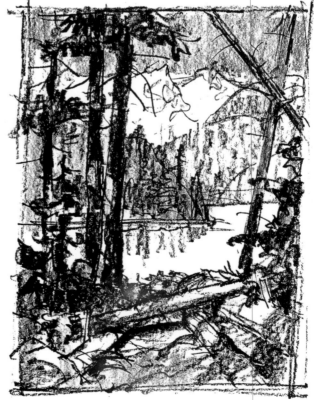

Two rough composition possibilities— drawn about the size of small postcards. Either solution could be made into a successful painting, but I felt the vertical composition might contribute to a feeling of height for the trees and the mountain peaks.

Basic Nature Painting Techniques in Watercolor

Step One

Pencil in the main elements of the picture. Then, begin applying light-valued hues of watercolor wash, keeping in mind the shapes. After dampening the lake area, paint it wet-in-wet, adding the reflected trees when the dampness is just right. Use a damp brush and clean water to lift the lake color from the tree trunks.

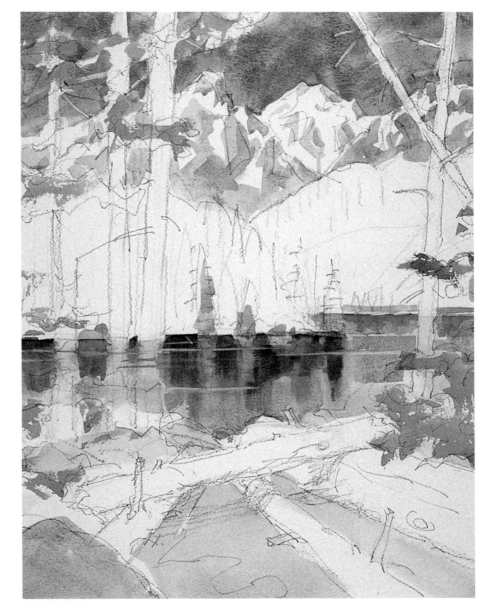

Step Two

The two forested hills across the lake should be painted in light values of greens. Paint the lightest values—both warms and cools—on the trees and logs, and add more foliage shapes.

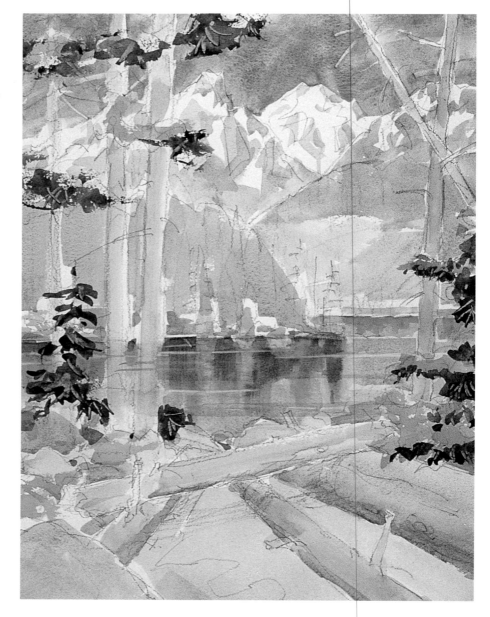

Basic Nature Painting Techniques in Watercolor

Step Three

Paint the tree shapes on the forested hills, mostly in middle to slightly darker values, and then the shadows on the trees, logs, rocks and so on. All the while, add the various greens of the foliage. The cast shadows, carefully observed and planned, should be added, and will help greatly in giving dimension to all the forms.

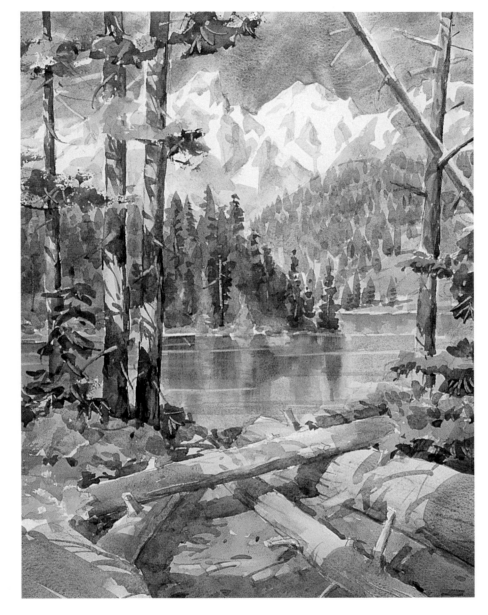

Step Four

More foliage shapes should be painted, as well as twigs, branches, etc. The two enlarged details on this page provide a good look at the warms and cools within the shadows, as well as some cool glazes laid over various foreground areas to pull them together. Note also the simple shapes of the reflections on the still water.

► *View Across String Lake*
16½" × 12¼" (41.9cm × 31.1cm)
Tom Hill

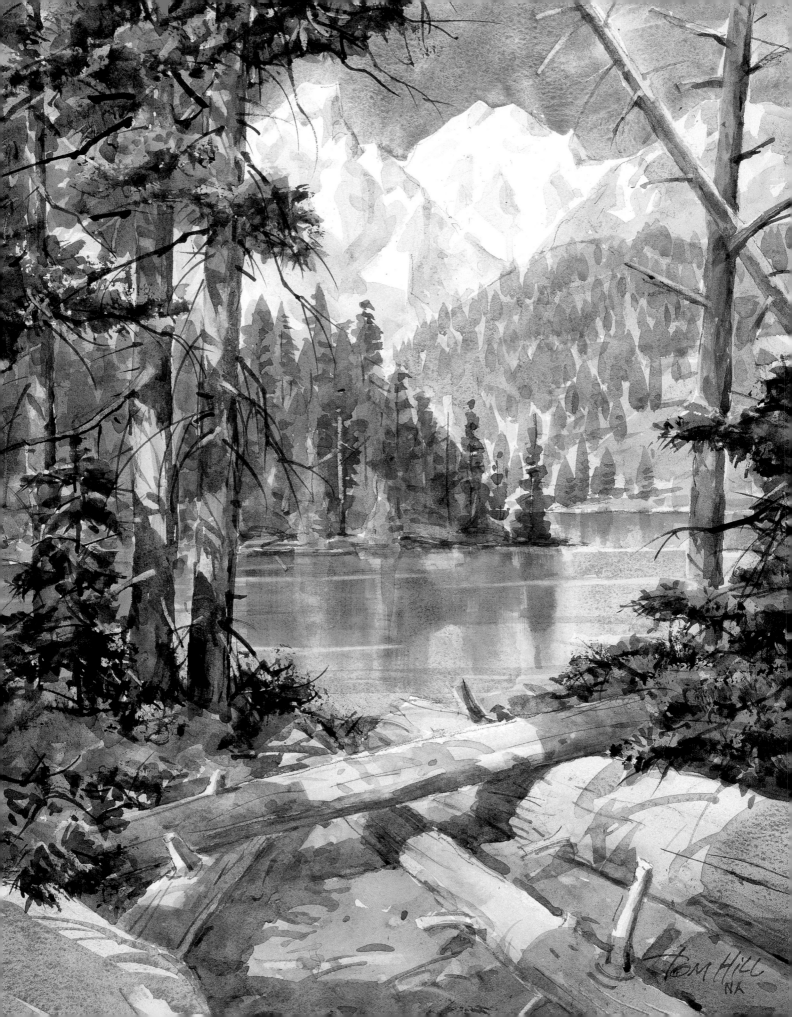

Painting a Series to Preserve a Place

—Charlene Engel

Painting multiple works that are connected by a common thread gives some artists the chance to explore a subject in depth. A collection of works presents a wider scope of a subject than one piece. This approach of developing a theme from more than one perspective appeals to many artists.

Preserving a Place

One of the most powerful examples of the series approach is Charlene Engel's work on Thomas Pond. She has spent two decades preserving images of this beautiful location in Maine. Getting to know the place intimately, she has painted almost every corner of the pond.

There is enormous variety within her continuing theme, as she captures individual pieces of the ever-changing whole. This career-long representation of a single subject allows her to address the issue of vanishing nature as she watches this beautiful region change.

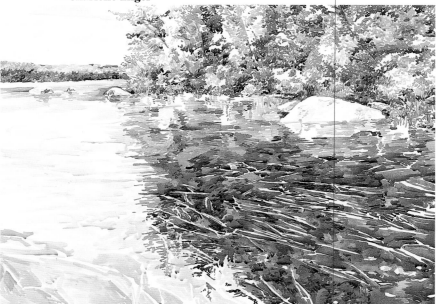

Capturing the Spirit of a Place *Near the end of his life, the Impressionist master Camille Pissarro remarked to his son, Lucien, that if he could have his life to do over, he would stay in one place for twenty-five years. In this way, he could really know that place well, capturing in his art the endless variety that is the essence of place.*

This sentiment is shared by Engel, who has returned to paint Thomas Pond, Maine, for the past two decades. Capturing the spirit of place, these paintings provide a record of the artist as well as her subject—a record of what is and what was.

Bass Country
22" × 30"
(55.9cm × 76.2cm)
Charlene Engel

Big Rocks, Bass Bay
15" × 22" (38.2cm × 55.9cm)
Charlene Engel

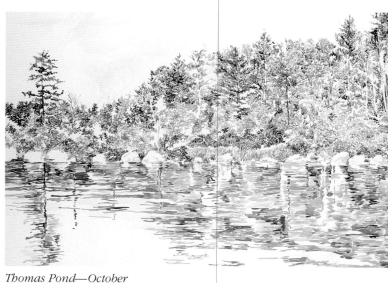

Thomas Pond—October
22" × 30" (55.9cm × 76.2cm)
Charlene Engel

Raymond Marsh—Sebago Lake
22" × 30" (55.9cm × 76.2cm)
Charlene Engel

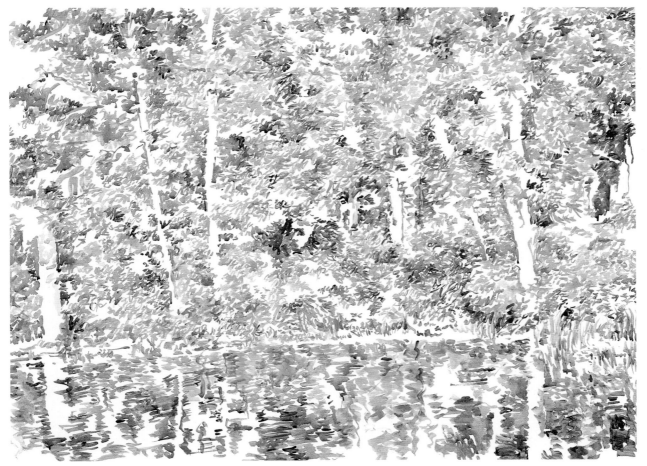

Thomas Pond 1992
22" × 30" (55.9cm × 76.2cm)
Charlene Engel

INDEX